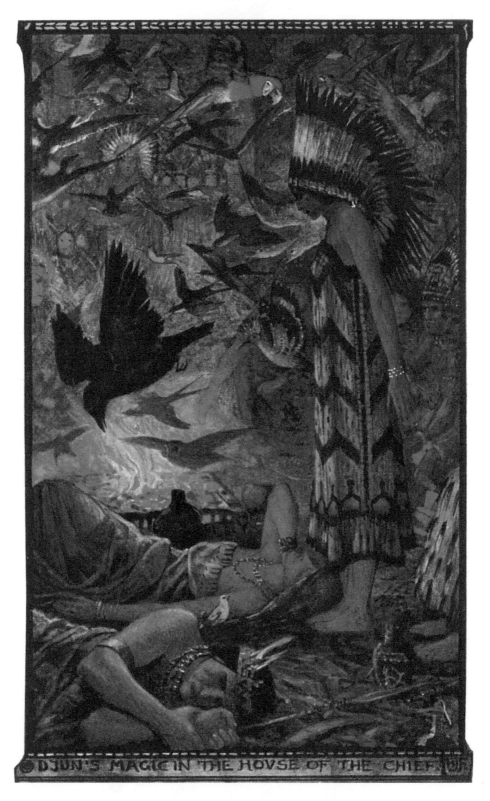

Djun's Magic in the House of the Chief
THE STORY OF DJUN
The Strange Story Book, 1913

Maidens, Monsters & Heroes

The Fantasy Illustrations of H. J. Ford

Selected and Edited by Jeff A. Menges

Dover Publications, Inc.
Mineola, New York

Bibliographical Note

Maidens, Monsters and Heroes: The Fantasy Illustrations of H. J. Ford, first published by Dover Publications, Inc., in 2010, is an original compilation of illustrations from the following sources, all selected and edited by Andrew Lang, illustrated by H. J. Ford, and published by Longmans, Green, and Co., London and New York, except where noted: *The Blue Fairy Book*, 1889; *The Red Fairy Book*, 1890; *The Green Fairy Book*, 1892; *The Yellow Fairy Book*, 1894; *The Red True Story Book*, 1895; *The Pink Fairy Book*, 1897; *The Arabian Nights Entertainments*, 1898; *The Red Book of Animal Stories*, 1899; *The Grey Fairy Book*, 1900; *The Violet Fairy Book*, 1901; *The Book of Romance*, 1902; *The Crimson Fairy Book*, 1903; *The Brown Fairy Book*, 1904; *The Orange Fairy Book*, 1906; *The Olive Fairy Book*, 1907; *Tales of Troy and Greece*, 1907; *The Book of Princes and Princesses*, selected by Mrs. Lang and edited by Andrew Lang, 1908; *The Lilac Fairy Book*, 1910; *The All Sorts of Stories Book*, selected by Mrs. Lang and edited by Andrew Lang, 1911; *The Book of Saints and Heroes*, selected by Mrs. Lang and edited by Andrew Lang, 1912; *The Strange Story Book*, selected by Mrs. Lang and edited by Andrew Lang, 1913; *Introduction to American History* by James Albert Woodburn and Thomas Francis Moran, 1916; and *Pilot and Other Stories* by Harry Plunket Greene, The Macmillan Company, New York, 1916.

Library of Congress Cataloging-in-Publication Data

Maidens, monsters and heroes: the fantasy illustrations of H.J. Ford / selected and edited by Jeff A. Menges.
 p. cm.
 Original compilation of illustrations from a variety of sources published between 1889 and 1916.
 ISBN-13: 978-0-486-47290-4
 ISBN-10: 0-486-47290-6
 1. Ford, H. J. (Henry Justice), 1860–1941—Themes, motives. 2. Fantasy in art. I. Ford, H. J. (Henry Justice), 1860–1941. II. Menges, Jeff A.
NC978.5.F65A4 2010
741.6092—dc22

 2009052977

Manufactured in the United States by LSC Communications
4500056073
www.doverpublications.com

INTRODUCTION

Henry Justice Ford grew up in the heart of the Victorian age. He was born in the environs of London in 1860, and spent most of his life there. The visual work he pro-duced would have the input and support of Britain's Victorian painters, including the Pre-Raphaelites, and he became part of—and influenced—the Golden Age of illustration. Ford's fairy-tale illustrations are some of the best known and most frequently reproduced works of the period.

Regarded as a strong student, H. J. Ford attended both the Slade School of Fine Art and the School of Art at Bushey, where he studied under Alphonse Legros and Sir Hubert von Herkomer. Though mostly remembered for his illustration work, Ford also was close to the fine artists of the period. Counted among the pre-Raphaelites himself, he was a good friend to prominent painter Edward Burne-Jones. In the earlier part of his career, Ford often exhibited landscape and imaginative works, but the success of his illustration work would steer the course of his later years.

Beginning in childhood, our experience with literature imprints certain concepts, including the battle between good and evil, the presence of magic, the expression of bravery, and the meaning of love. They are built upon the foundations of the stories collected by Grimm, D'Aulunoy, and Andersen, and are passed on down to us from the earliest myths and legends.

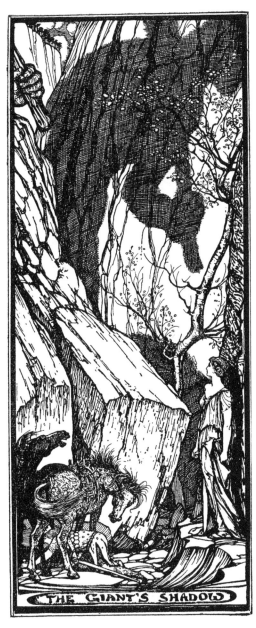

The Giant's Shadow
THE KING OF THE WATERFALLS
The Lilac Fairy Book, 1910

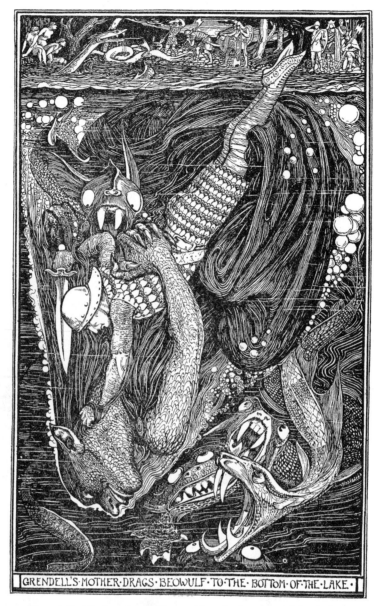

GRENDELL·S·MOTHER·DRAGS·BEOWULF·TO·THE·BOTTOM·OF·THE·LAKE·

Grendel's Mother drags Beowulf to the bottom of the Lake
THE STORY OF BEOWULF, GRENDEL, AND GRENDEL'S MOTHER
The Red Book of Animal Stories, 1899

Many of the iconic elements that populate the tales of youth of the Edwardian era sprang from the pages of author and editor Andrew Lang's "Color" fairy books. In fact, some of the earliest, most widely printed imagery came from this series, produced in Britain from 1889 to 1910. Over that twenty-one-year stretch, Andrew Lang combed through a sizable collection of tales to select the best stories; the resulting twelve volumes are full of imagery. The initial volume, the *Blue Fairy Book,* was released in 1889, and contained illustrations by G. P. Jacomb Hood, as well as twenty-nine-year-old Henry Justice Ford. Lang's second volume featured artwork by Ford and Lancelot Speed. As the series became increasingly popular, and as more volumes were released, other illustrators were dropped from the project. In 1892, with the *Green*

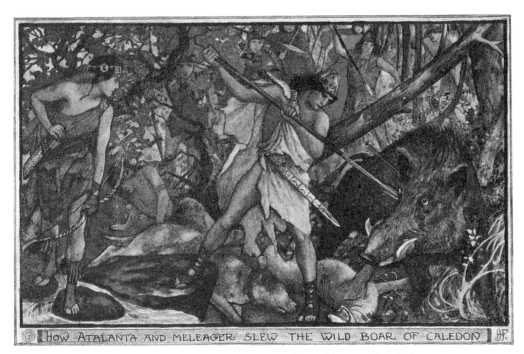

How Atalanta and Meleager slew the Wild Boar of Caledon
MELEAGER THE HUNTER
The All Sorts of Stories Book, 1911

Fairy Book, H. J. Ford became the sole illustrator, and he would remain so for the next nine volumes, over the next eighteen years. In this series alone, Ford produced a staggering number of images—more than 1,000— each volume presenting approximately 100 illustrations.

The relationship between Andrew Lang and H. J. Ford was mutually beneficial. There were few books in British children's literature that were as popular as the "Color" fairy books, and the pairing was so successful that, after Andrew Lang's passing in 1912, Longman's, Green and Co. continued to publish works with Lang's name—along with Mrs. Lang's (she contributed greatly to the later volumes). Ford worked with Mrs. Lang on titles such as *The Book of Princes and Princesses, The Book of Saints and Heroes,* and *The All Sorts of Stories Book.* After World War I, with the resulting drop in book production and the Lang fairy books behind him, Ford found fewer assignments. His last book, issued in 1921, was an edition of Bunyan's *Pilgrim's Progress.* Ford died in 1941, leaving a wealth of images deeply planted in the imaginations of a generation.

Jeff A. Menges
October 2009

CONTENTS

The selected illustrations are a sampling of the art from each of the listed volumes. All volumes were originally published by Longman's, Green, and Co., with the exception of *Pilot and Other Stories*, which was published by The Macmillan Company.

Part I: Early Line Work

Part II: The Addition of Color

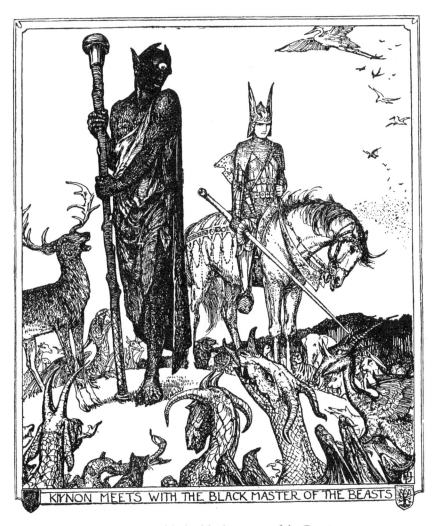

Kynon meets with the black master of the Beasts
THE LADY OF THE FOUNTAIN
The Lilac Fairy Book, 1910

Part I: Early Line Work

In the original "Blue" book of Andrew Lang's fairy series, the work done by H. J. Ford was competent and capable, but Ford had not yet defined a signature style. While the stories were fantastic and full of magic, Ford's earliest illustrations were typical of the period. The artwork that Lang's books required was daunting—the books averaged one hundred drawings per volume, and while the first two volumes featured two illustrators, Ford took on the remaining volumes alone. While not every image filled a full page, most did, and many were extremely complex. Horses, multiple figures, period and regional dress and armor—all became the necessary ingredients for the illustrations in the books that Lang produced. Ford became *very* good at assembling imagery that contained both the reference of real history and the wildest imaginings. By the fourth volume, the *Yellow Fairy Book*, Ford's work had developed a character of its own—complex and defined—and his inking had become masterful. He developed an excellent sense of how values and textures could be used to move the viewer around the image.

The Three Grey Sisters
THE TERRIBLE HEAD
The Blue Fairy Book, 1889

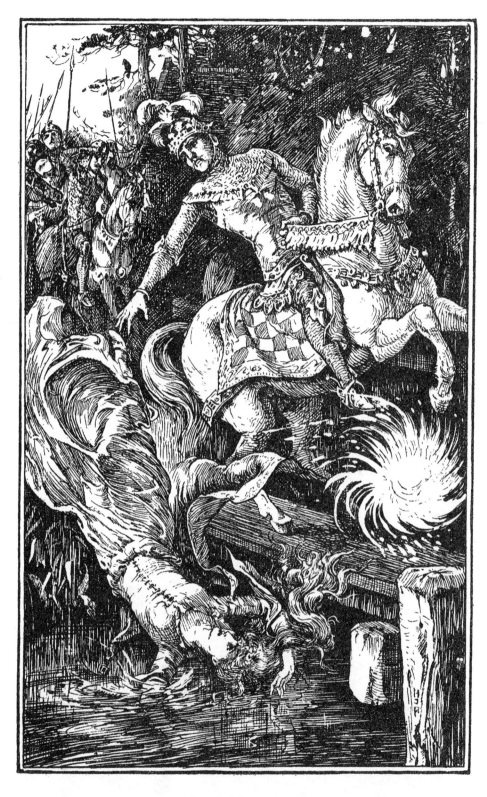

The Gold-spinners
THE WATER LILY. THE GOLD SPINNERS

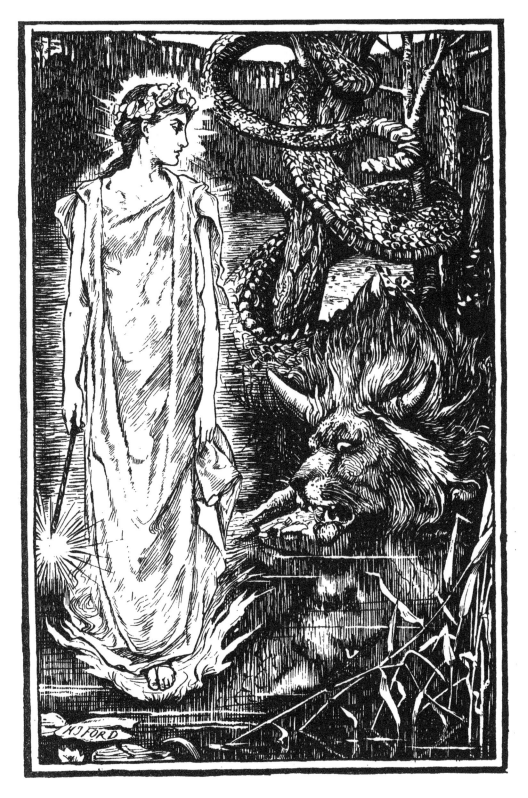

Prince Darling transformed into the Monster
PRINCE DARLING

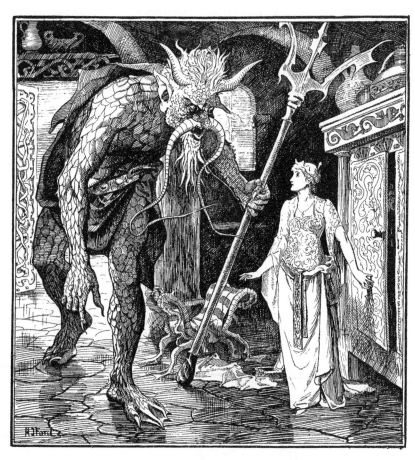

Top: "Yes, it must be that," said the Troll
MINNIKIN
Bottom: "Well, my little foal, you are a fine fellow!"
DAPPLEGRIM

The Red Fairy Book, 1890

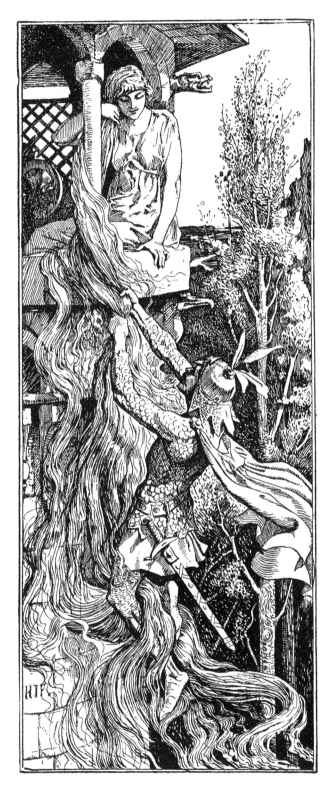

"Let down your golden hair"
RAPUNZEL

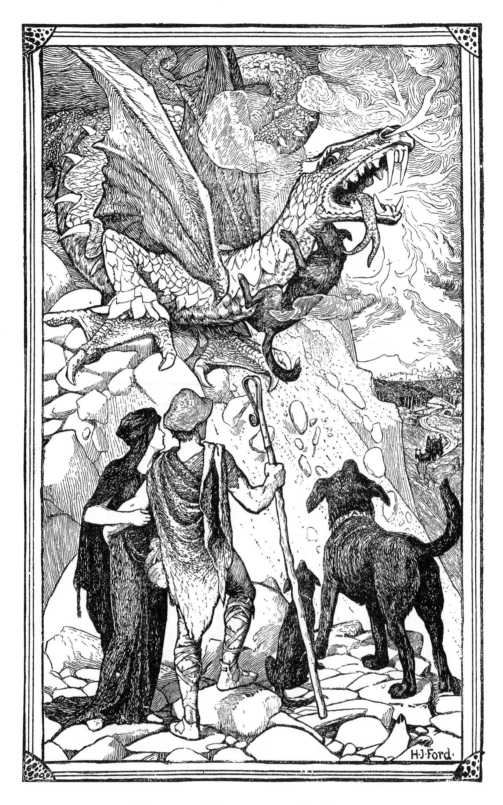

The second dog set upon the dragon
THE THREE DOGS

The Green Fairy Book, 1892

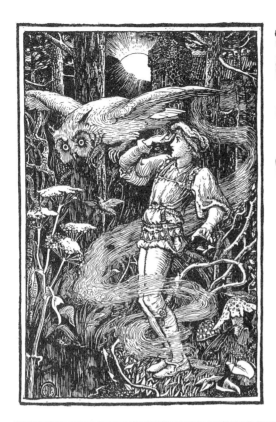
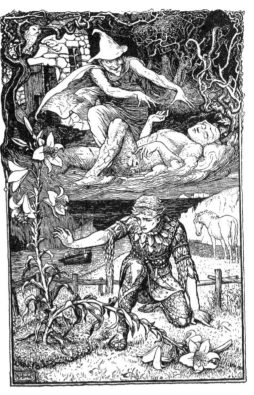
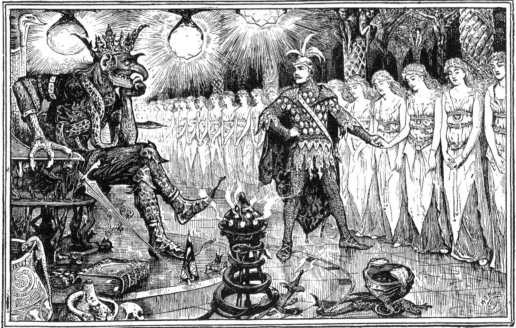

Top left: A night-owl with glowing eyes flew three times round her
JORINDE AND JORINGEL
Top right: "The golden lilies will tell you all about us"
THE GOLDEN LADS
Bottom: "This is the Princess Hyacinthia!"
KING KOJATA

The Green Fairy Book, 1892

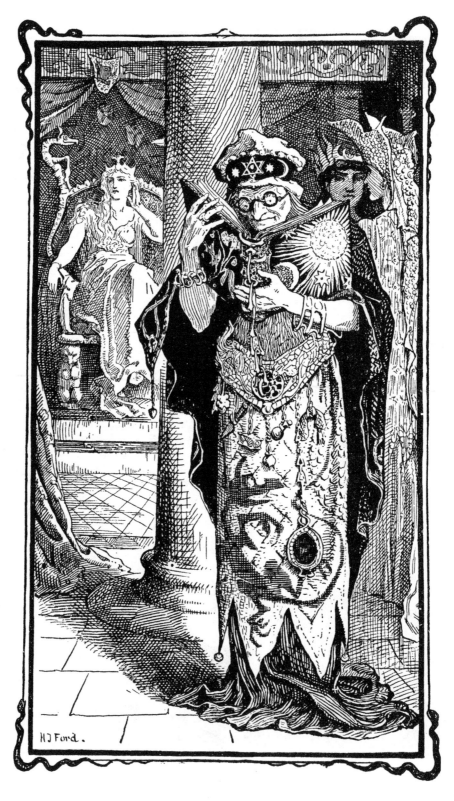

Thereupon the eldest Fairy consulted her Book of Magic
HEART OF ICE

The Green Fairy Book, 1892

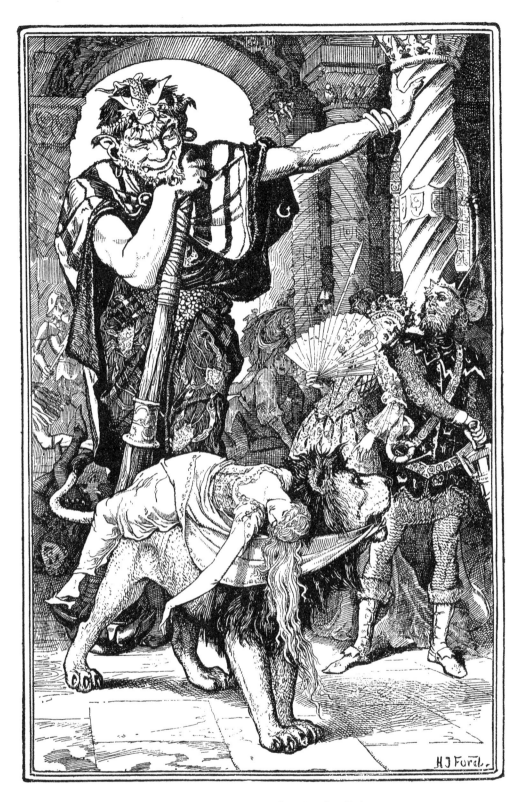

Grumedan's Lion Fetches in the Princess
PRINCE NARCISSUS AND THE PRINCESS POTENTILLA

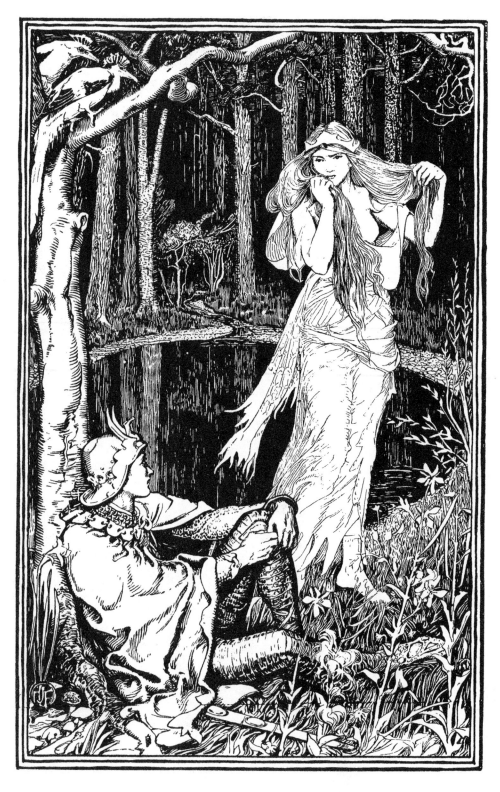

The Witch-maiden sees the Young Man under a Tree
THE DRAGON OF THE NORTH

The Yellow Fairy Book, 1894

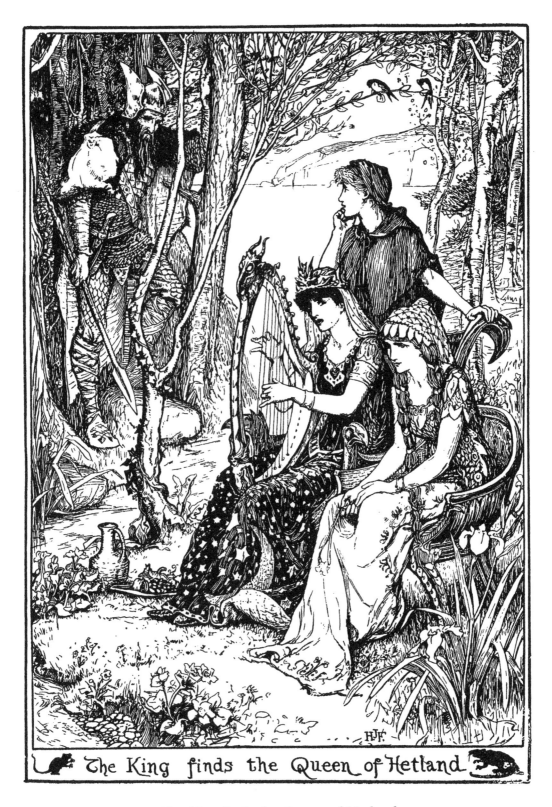

The King finds the Queen of Hetland

HERMOD AND HADVOR

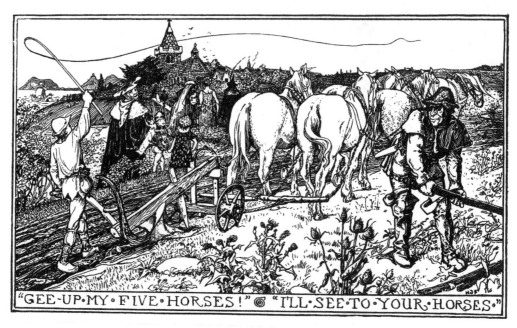

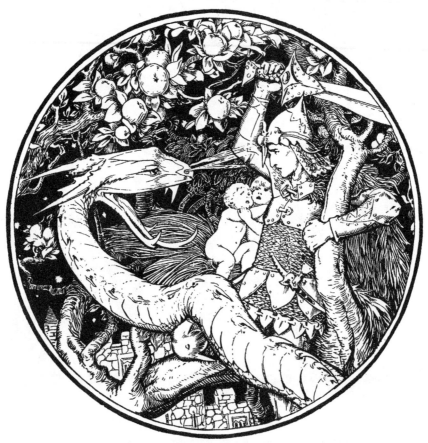

Top: "Gee-up my five horses!" "I'll see to your horses"
THE STORY OF BIG KLAUS AND LITTLE KLAUS
Bottom: "Then the youth swung his mighty sword in the air,
and with one blow cut off the serpent's head"
THE THREE BROTHERS

The Yellow Fairy Book, 1894

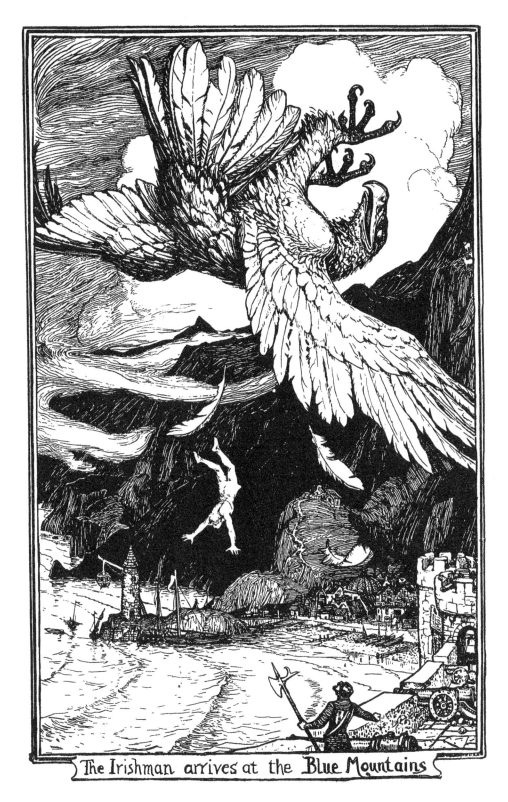

The Irishman arrives at the Blue Mountains
THE BLUE MOUNTAINS

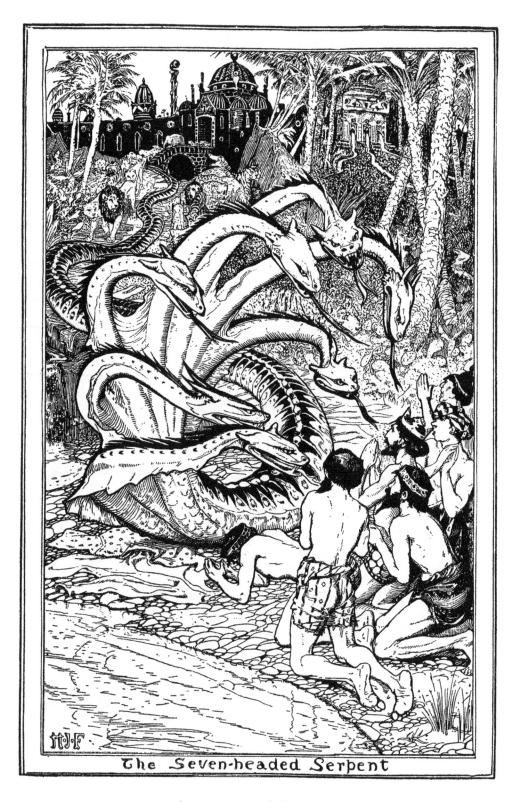

The Seven-headed Serpent

The Seven-headed Serpent
THE SEVEN-HEADED SERPENT

The Yellow Fairy Book, 1894

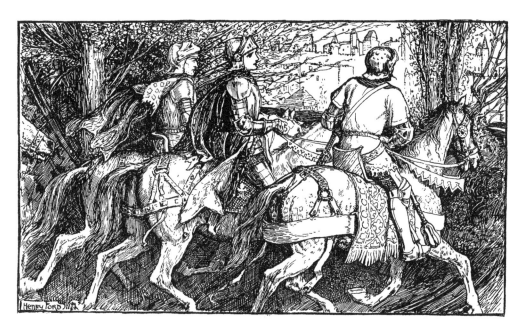

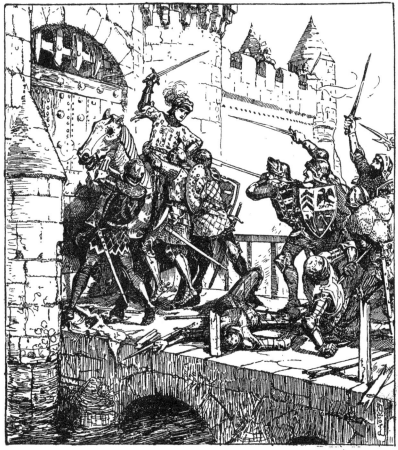

Top: Joan rides to Chinon
THE LIFE AND DEATH OF JOAN THE MAID
Bottom: Joan captured
THE LIFE AND DEATH OF JOAN THE MAID

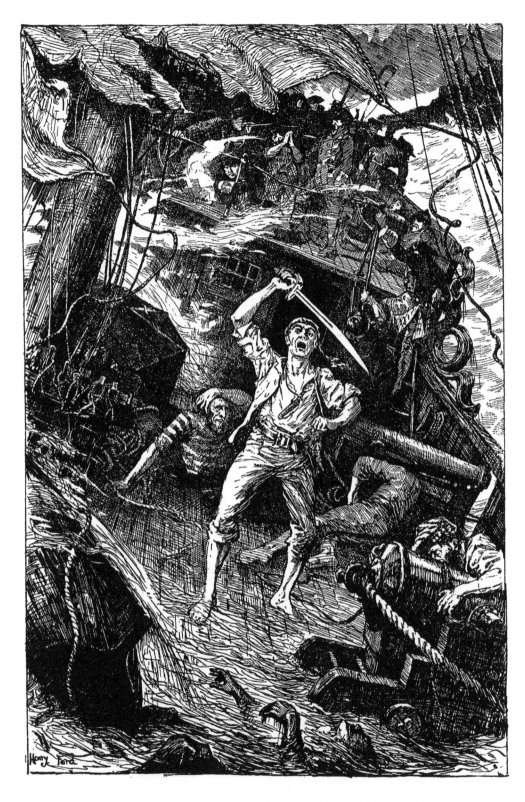

"One man . . . stalked about the deck and flourished a cutlass . . .
shouting that he was 'king of the country'"
THE WRECK OF THE "WAGER"

The Red True Story Book, 1895

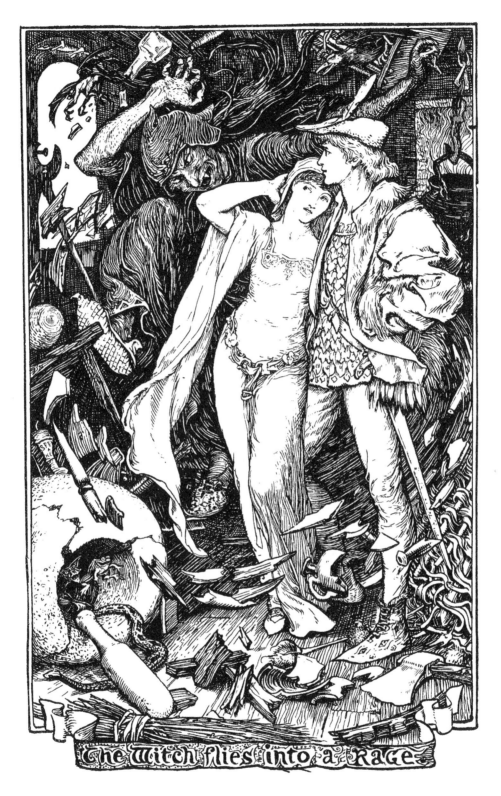

The Witch flies into a Rage
THE WHITE DOVE

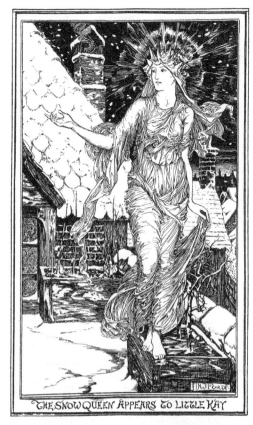

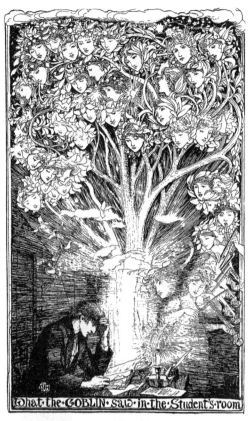

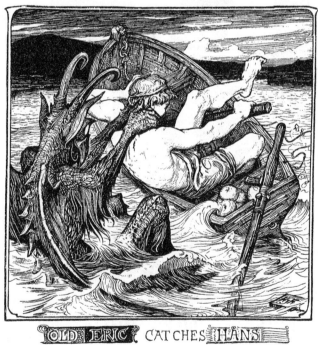

Top left: The Snow Queen appears to Little Kay
THE SNOW-QUEEN
Top right: What the Goblin saw in the Student's room
THE GOBLIN AND THE GROCER
Bottom: Old Eric catches Hans
HANS, THE MERMAID'S SON

18

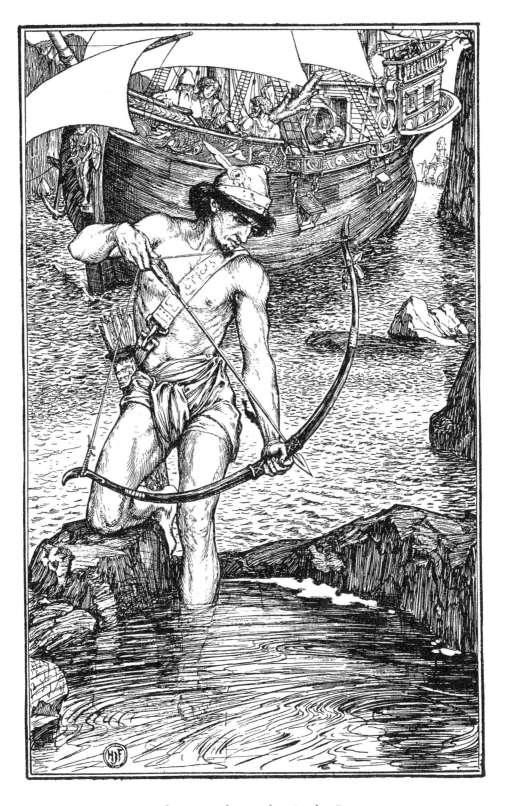

How they met the Archer in the Stream

HOW THE HERMIT HELPED TO WIN THE KING'S DAUGHTER

The Pink Fairy Book, 1897

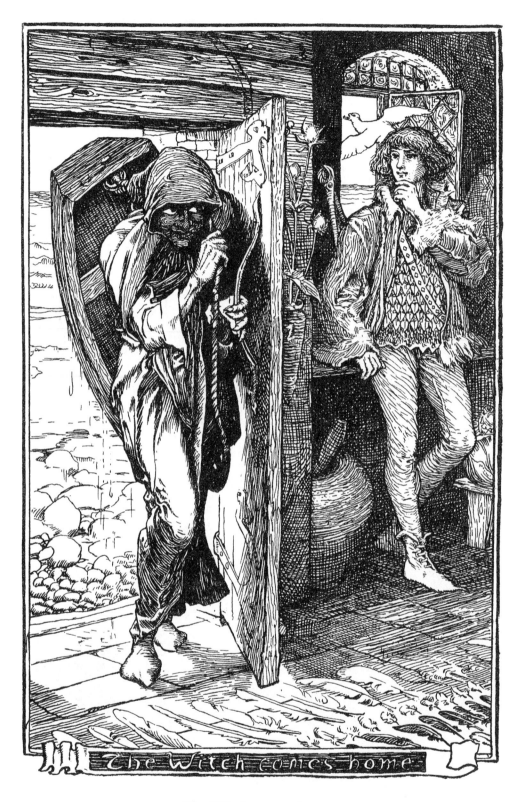

The Witch comes home
THE WHITE DOVE

The Pink Fairy Book, 1897

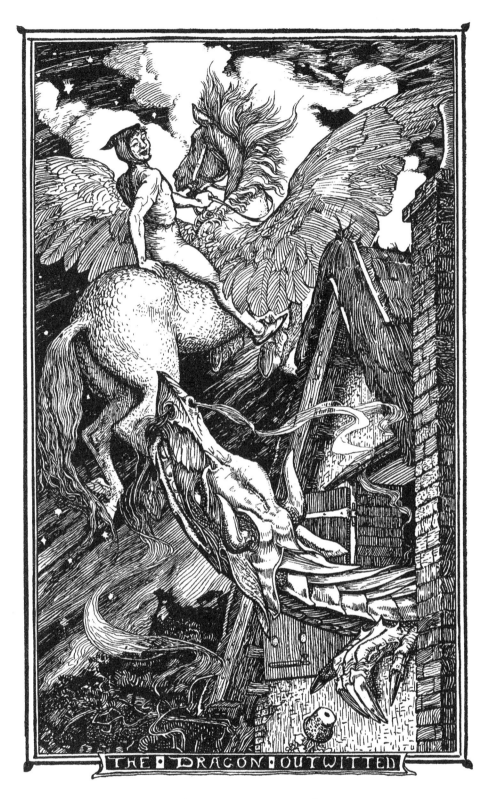

THE · DRAGON · OUTWITTED

The Dragon outwitted
HOW THE DRAGON WAS TRICKED

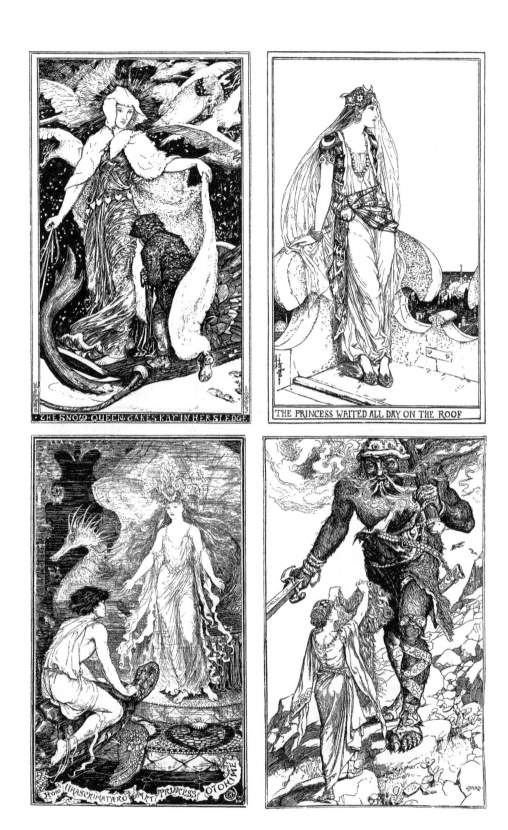

Top left: The Snow-queen takes Kay in her sledge, THE SNOW-QUEEN
Top right: The Princess waited all day on the roof, THE FLYING TRUNK
Bottom left: How Uraschimataro met Princess Otohimé
URASCHIMATARO AND THE TURTLE
Bottom right: The Maiden brings the coat of hair to the Giant
THE WOUNDED LION

The Pink Fairy Book, 1897

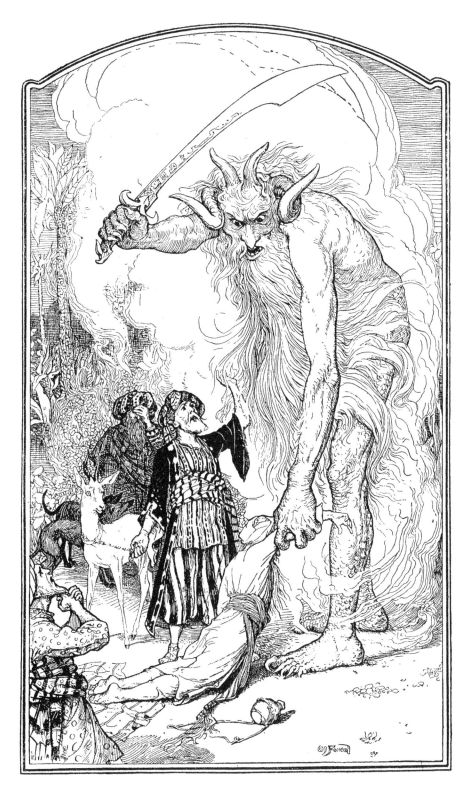

The Genius and the Merchants
THE STORY OF THE MERCHANT AND THE GENIUS

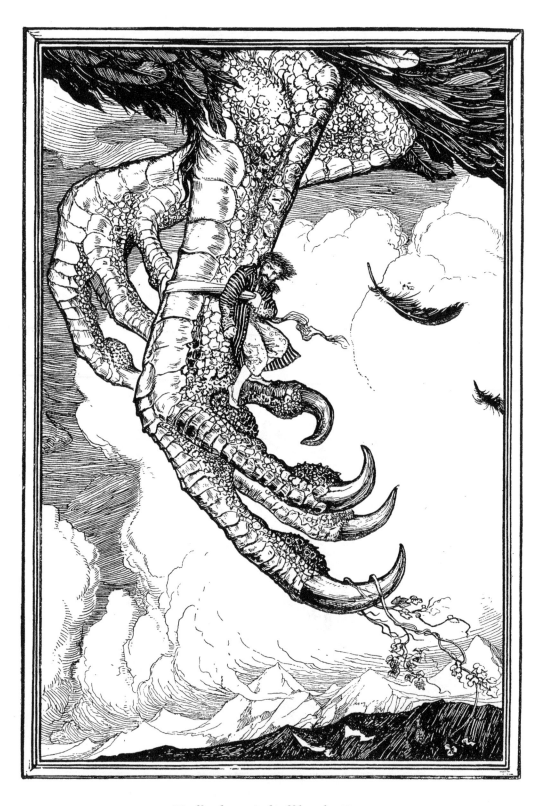

Sindbad carried off by the Roc
THE SECOND VOYAGE

The Arabian Nights Entertainments, 1898

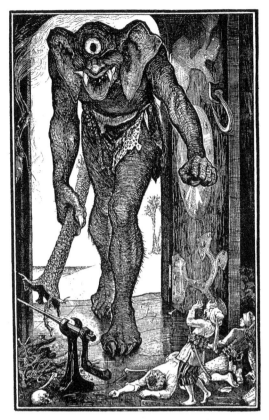

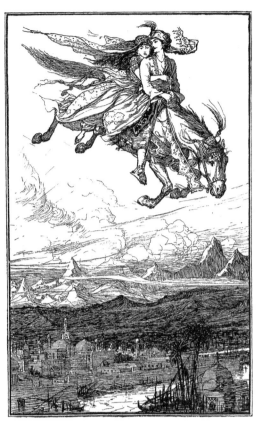

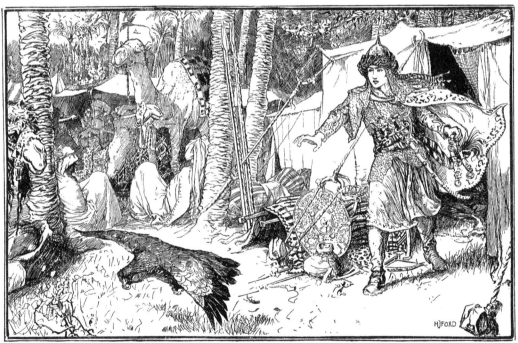

Top left: The Giant enters, THE THIRD VOYAGE
Top right: The Prince and Princess arrive at the Capital of Persia
on the Enchanted Horse
THE ENCHANTED HORSE
Bottom: The Bird flies off with the Talisman
THE ADVENTURES OF PRINCE CAMARALZAMAN AND THE PRINCESS BADOURA

The Arabian Nights Entertainments, 1898

25

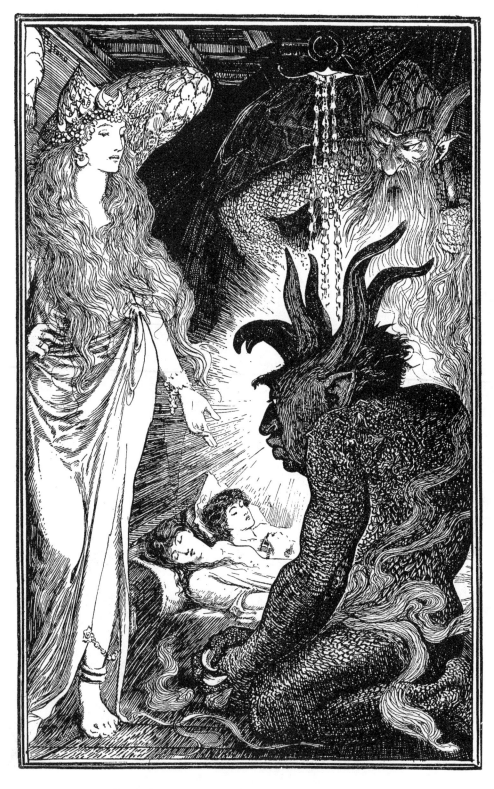

Caschcasch is unable to decide which is the Fairer
THE ADVENTURES OF PRINCE CAMARALZAMAN AND THE PRINCESS BADOURA

The Arabian Nights Entertainments, 1898

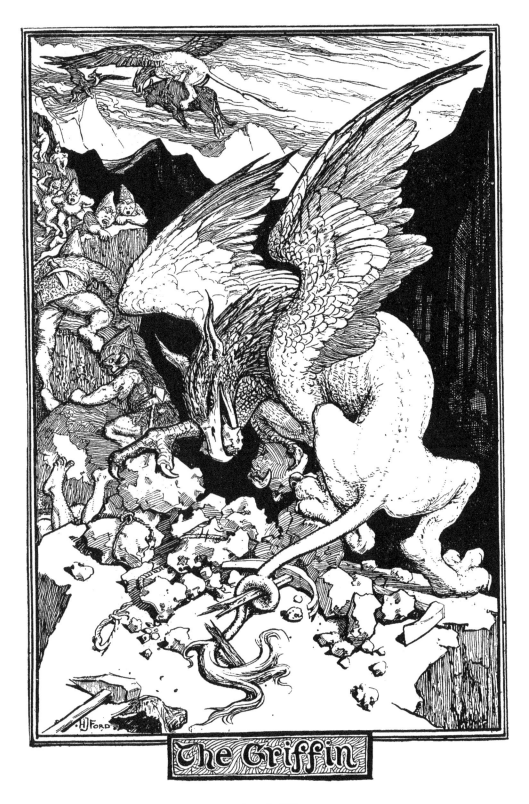

The Griffin

The Griffin
GRIFFINS AND UNICORNS

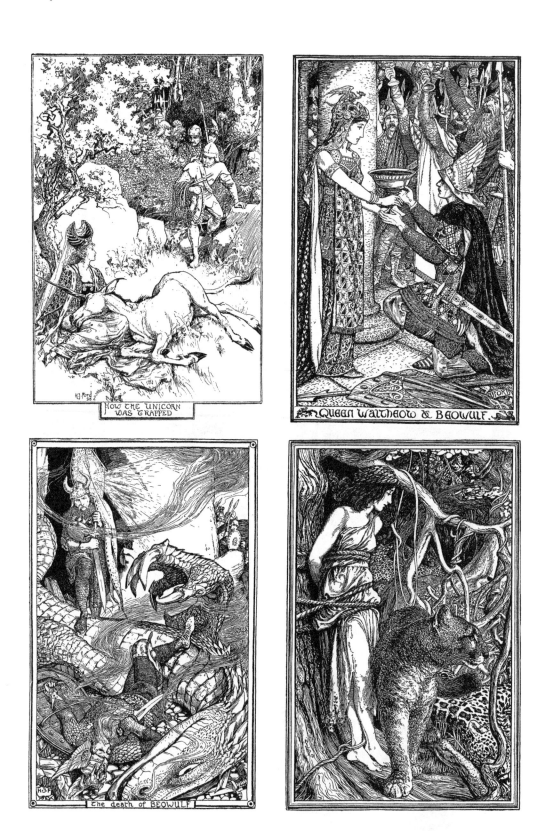

Top left: How the Unicorn was trapped, GRIFFINS AND UNICORNS
Top right: Queen Waltheow & Beowulf
THE STORY OF BEOWULF, GRENDEL, AND GRENDEL'S MOTHER
Bottom left: The Death of Beowulf, THE STORY OF BEOWULF AND THE FIRE DRAKE
Bottom right: Maldonada guarded by the Puma
PUMAS AND JAGUARS IN SOUTH AMERICA

The Red Book of Animal Stories, 1899

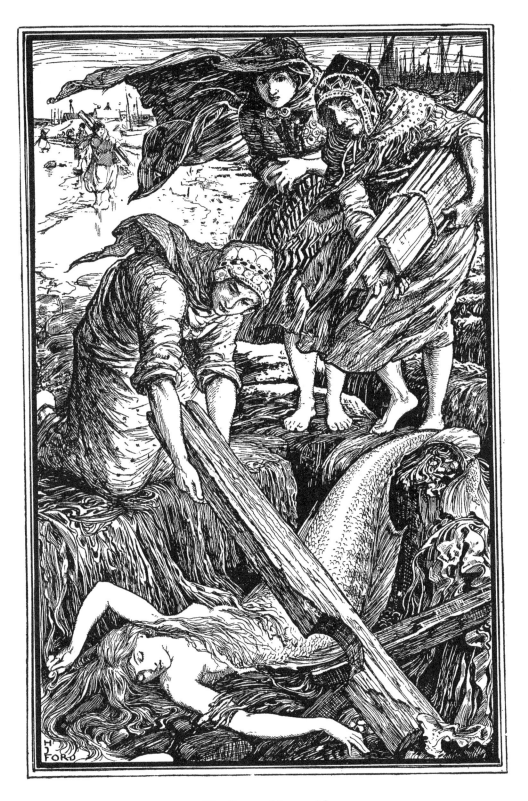

Finding a Mermaid
ABOUT ANTS, AMPHISBÆNAS, AND BASILISKS

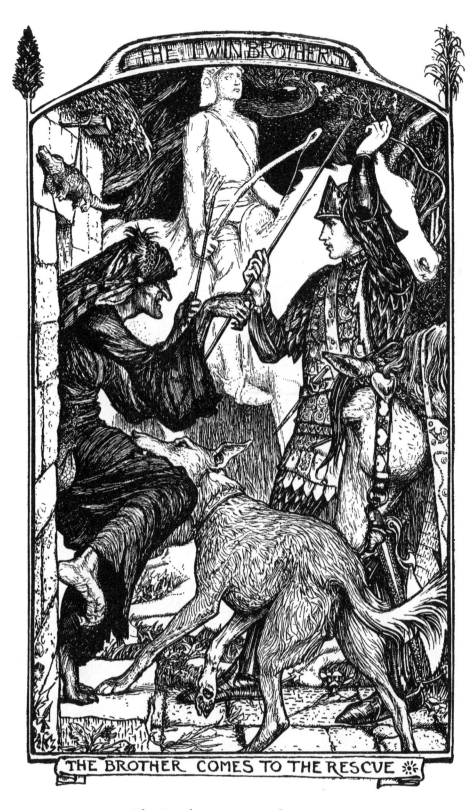

THE TWIN BROTHERS

THE BROTHER COMES TO THE RESCUE ✲

The Brother comes to the Rescue
THE TWIN BROTHERS

The Grey Fairy Book, 1900

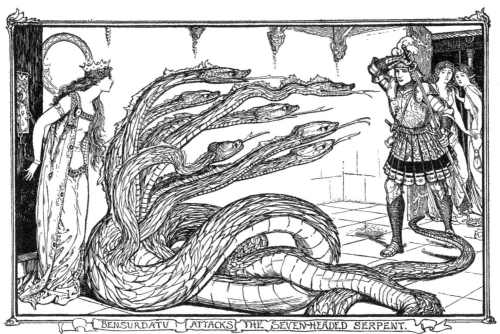

BENSURDATU ATTACKS THE SEVEN-HEADED SERPENT.

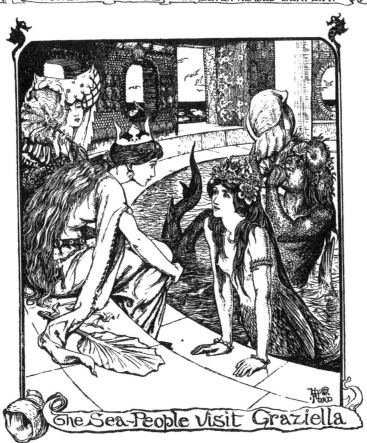

The Sea-People visit Graziella

Top: Bensurdatu attacks the Seven-headed Serpent
THE STORY OF BENSURDATU
Bottom: The Sea-People Visit Graziella
AN IMPOSSIBLE ENCHANTMENT

Part II: The Addition of Color

In the late nineteenth century, color lithographic printing had begun to appear in commercial markets. When it was first used in book printing, it appeared as flat expanses of color filling in heavy line, similar to screen-printing. The public's interest in color drove the industry to rapid improvements, and, by 1900, full-color images could be reproduced with a fair degree of accuracy.

At this time, Lang's "Color" fairy books were extremely popular, and in the middle of what would be their twenty-plus-year run. H. J. Ford was first given the opportunity to produce color pieces in 1901 for *The Violet Fairy Book*. Not unlike his early inks, the color work in his earliest attempts show some experimentation. He preferred watercolor as a medium, and in most cases his original works are similar in size to the hundreds of ink works he had been producing for years. His most ambitious color illustrations may have been the works done in 1916 for *Introduction to American History*. These pieces have much of the storytelling ability that Ford's best ink pieces maintain, while taking advantage of color to set a mood.

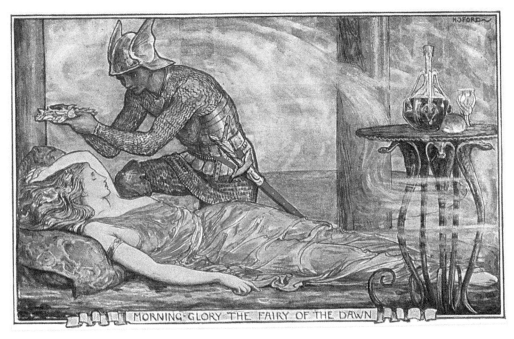

Morning Glory, The Fairy of the Dawn
THE FAIRY OF THE DAWN
The Violet Fairy Book, 1901

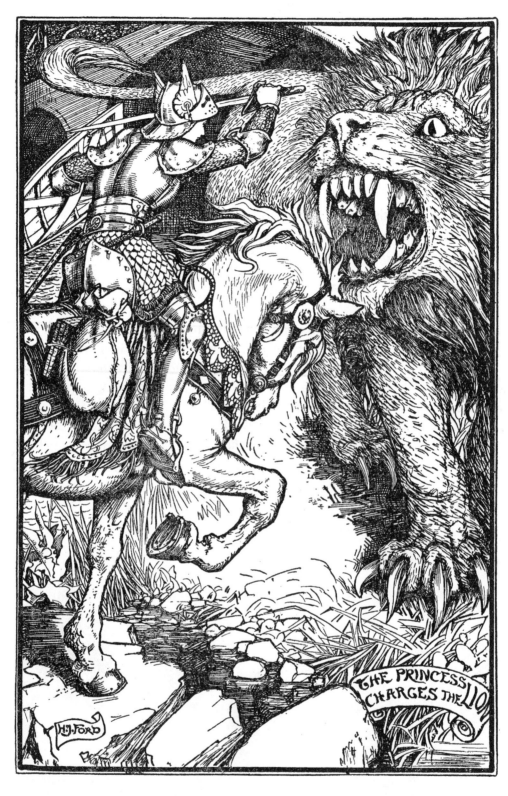

The Princess charges the Lion

T<small>HE</small> G<small>IRL WHO PRETENDED TO BE A</small> B<small>OY</small>

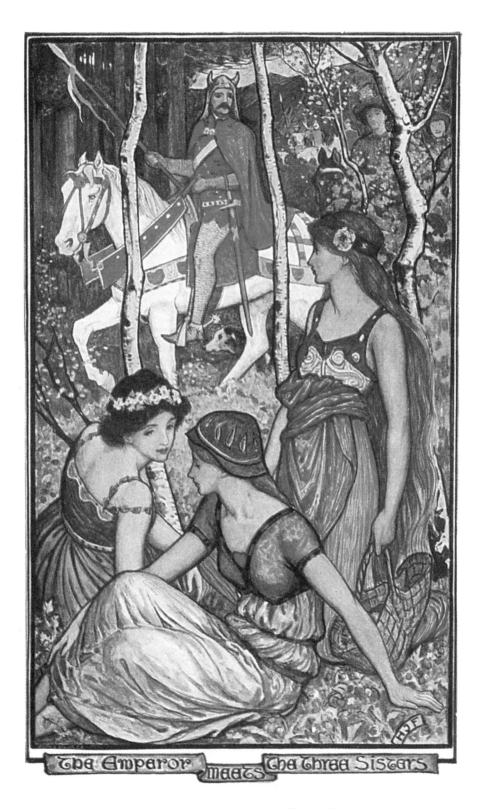

The Emperor meets the Three Sisters
THE BOYS WITH THE GOLDEN STARS

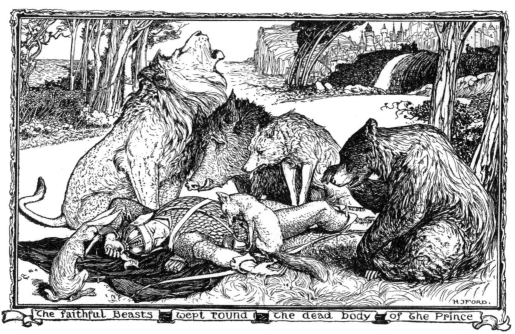

The faithful Beasts wept round the dead body of the Prince

Top: The faithful Beasts wept round the dead Body of the Prince
THE THREE PRINCES AND THEIR BEASTS
Bottom: The Dragon Alarmed
STAN BOLOVAN

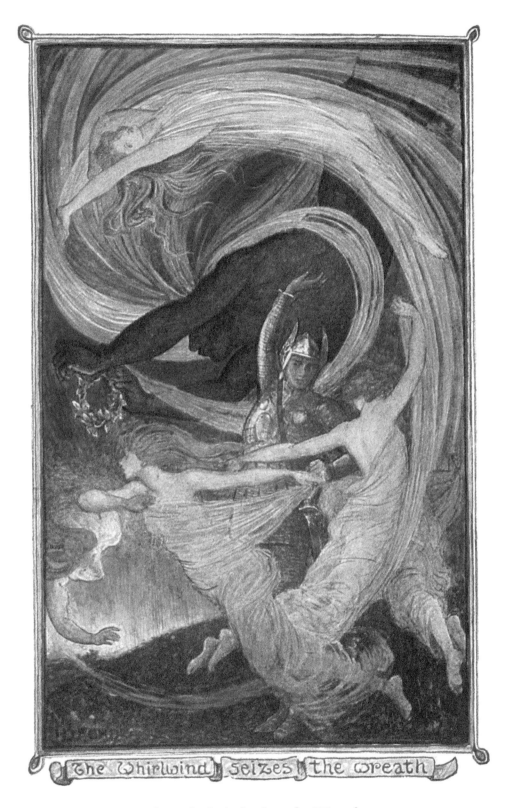

The Whirlwind seizes the Wreath
THE FAIRY OF THE DAWN

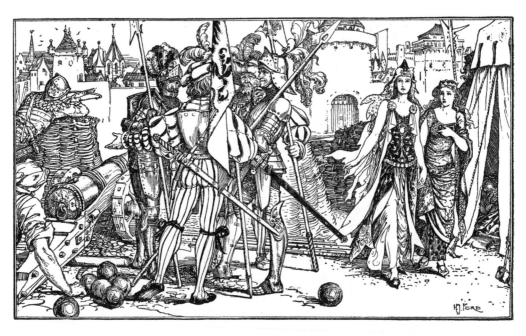

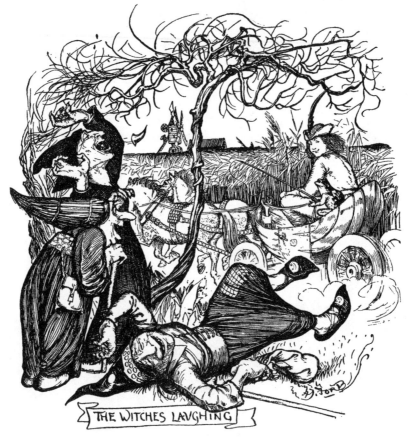

The Fairy and Dotterine pass unseen through the Camp of the Enemy
THE CHILD WHO CAME FROM AN EGG
The Witches laughing
THE FROG

The Violet Fairy Book, 1901

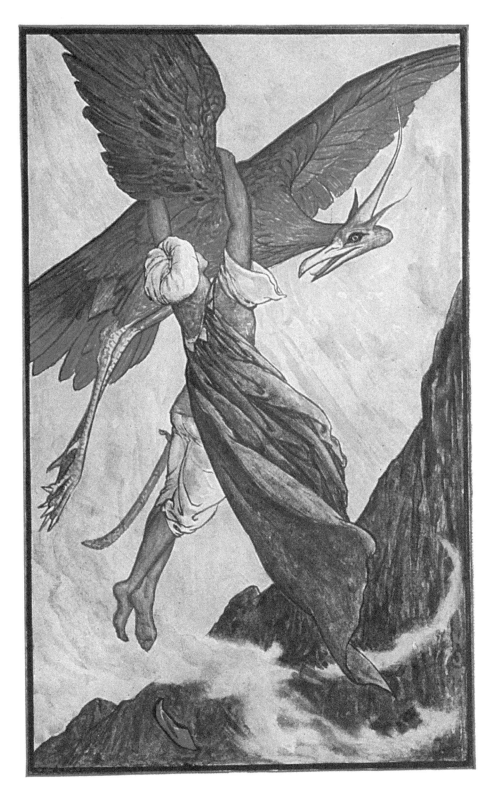

The Nunda, Eater of People
THE NUNDA, EATER OF PEOPLE

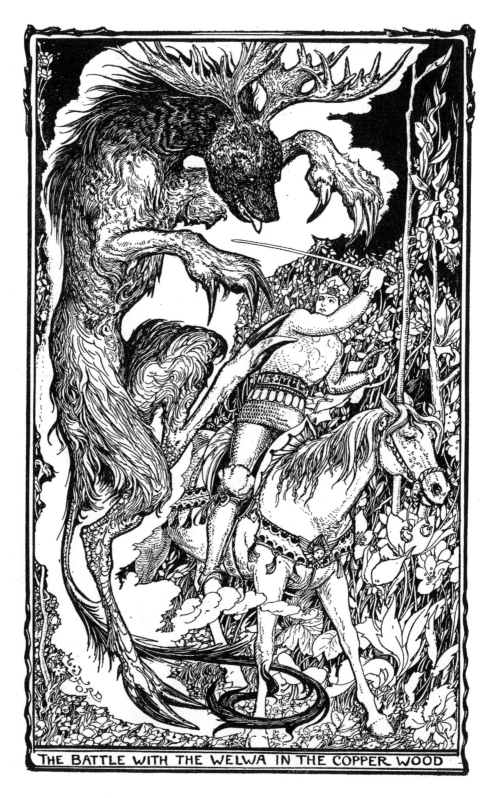

THE BATTLE WITH THE WELWA IN THE COPPER WOOD

The Battle with the Welwa in the Copper Wood
THE FAIRY OF THE DAWN

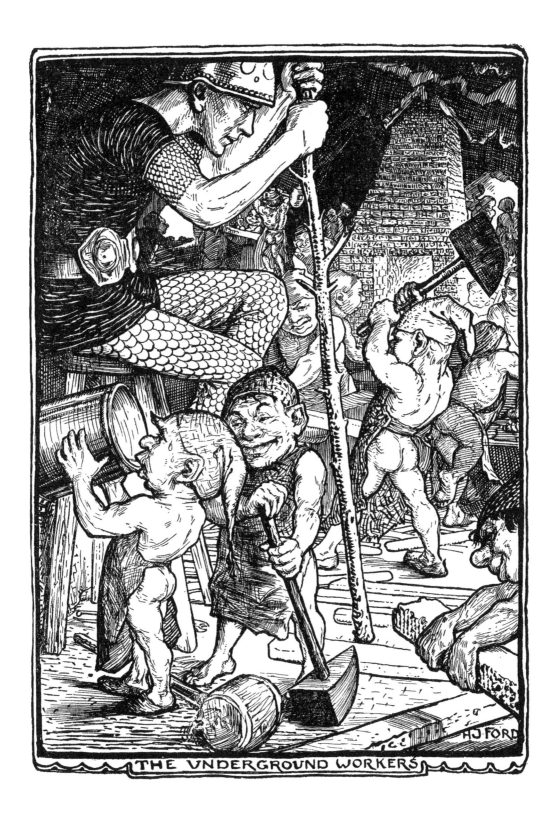

THE UNDERGROUND WORKERS

The Underground Workers
THE UNDERGROUND WORKERS

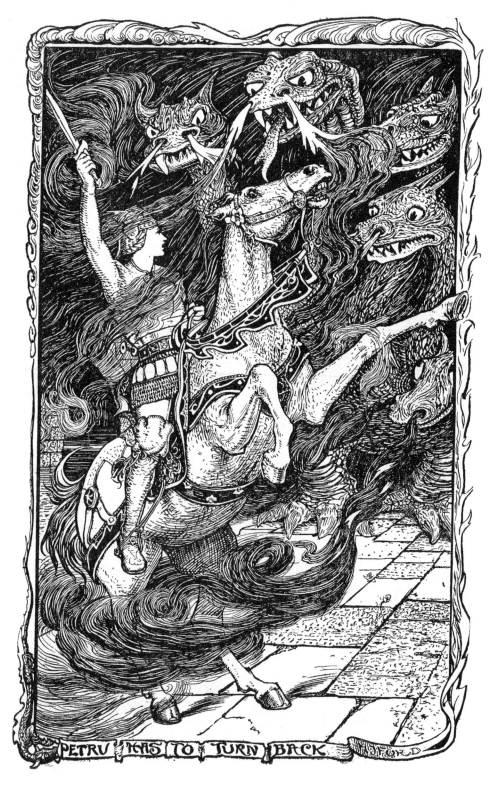

Petru has to turn back
THE FAIRY OF THE DAWN

The Violet Fairy Book, 1901

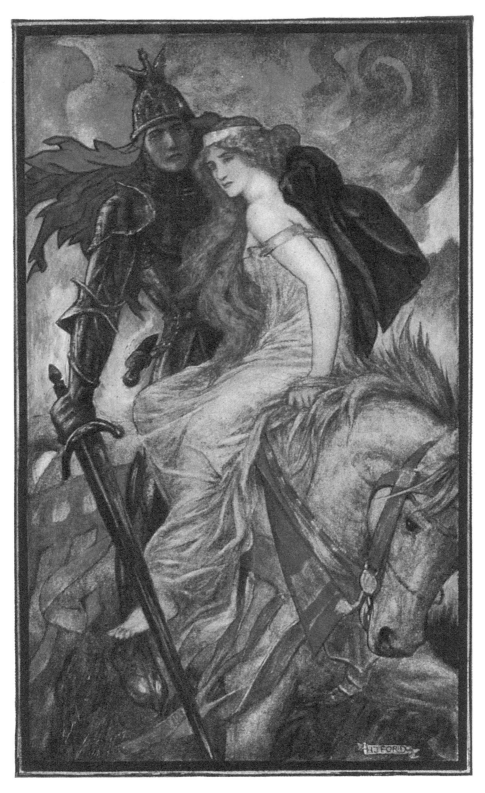

Lancelot bears off Guenevere

LANCELOT AND GUENEVERE

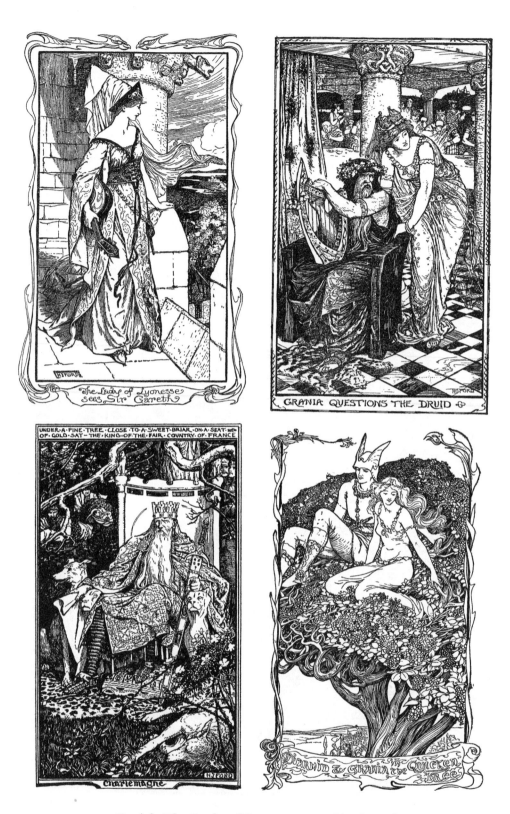

Top left: The Lady of Lyoness sees Sir Gareth
WHAT BEAUMAINS ASKED OF THE KING
Top right: Grania Questions the Druid, THE PURSUIT OF DIARMID
Bottom left: Charlemagne, THE BATTLE OF RONCEVALLES
Bottom right: Diarmid and Grania in the Quicken Tree
THE PURSUIT OF DIARMID

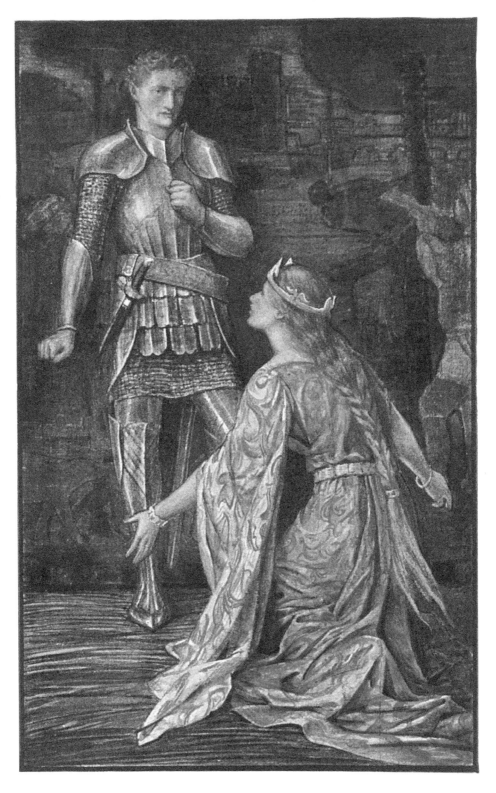

Guenevere and Sir Bors
THE FIGHT FOR THE QUEEN

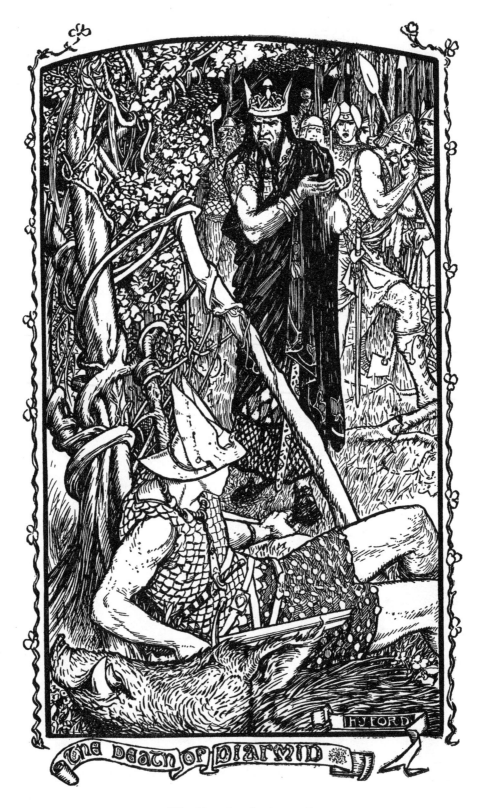

The Death of Diarmid
THE PURSUIT OF DIARMID

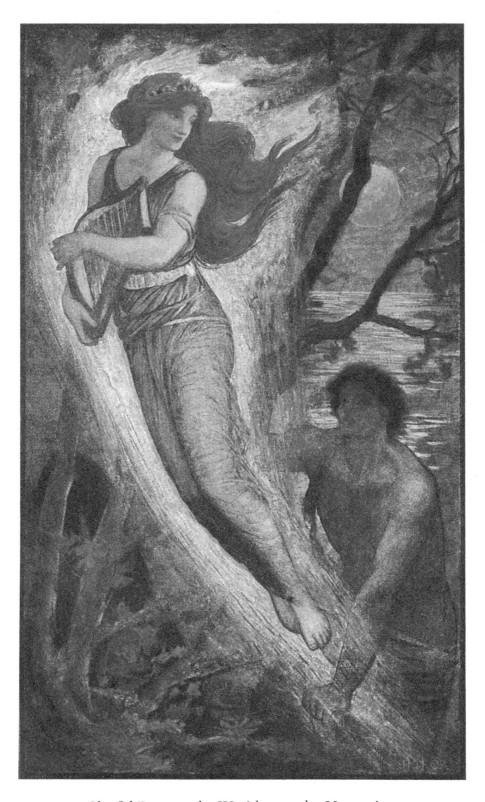

Slagfid Pursues the Wraith over the Mountains
WAYLAND THE SMITH

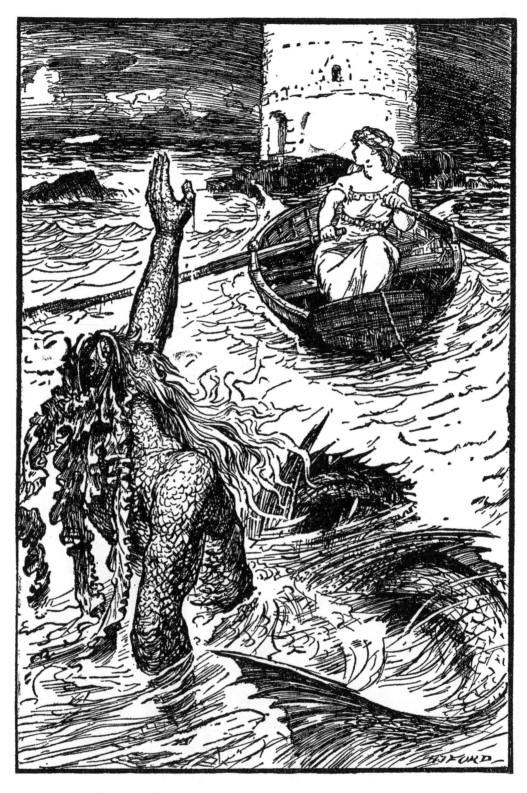

The Merman Warns Banvilda in Vain
WAYLAND THE SMITH

The Book of Romance, 1902

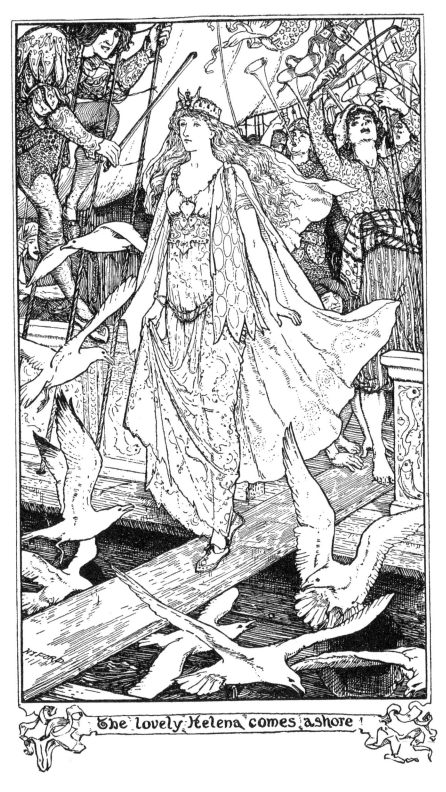

The lovely Helena comes ashore

The lovely Helena comes ashore
THE STORY OF THE SEVEN SIMONS

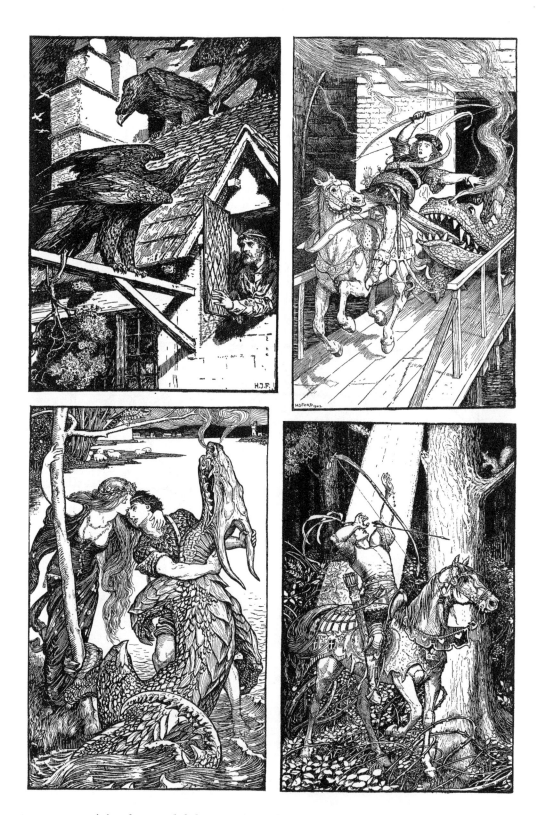

Top left: The Faithful Servant and the Three Eagles, LUCKY LUCK
Top right: How the Dragon caught the Prince
THE PRINCE AND THE DRAGON
Bottom left: The Kiss that gave the Victory
THE PRINCE AND THE DRAGON
Bottom right: The Ray of Light, LITTLE WILDROSE

The Crimson Fairy Book, 1903

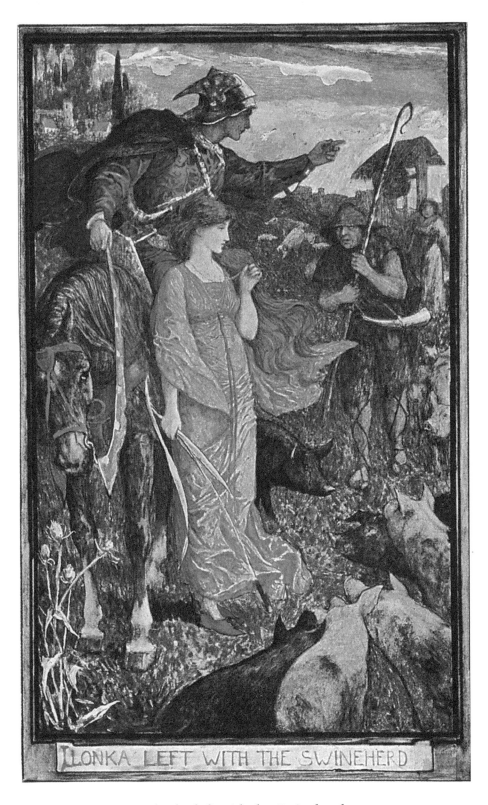

Ilonka left with the Swineherd
LOVELY ILONKA

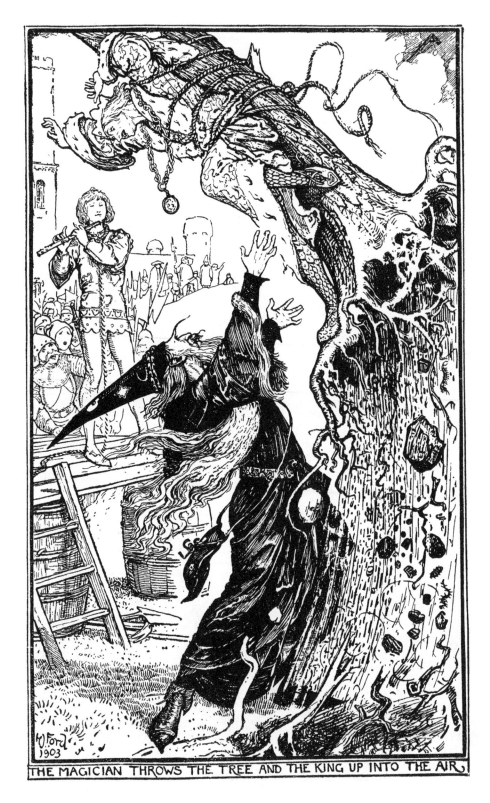

The Magician throws the Tree and the King up into the Air
THE GIFTS OF THE MAGICIAN

The Crimson Fairy Book, 1903

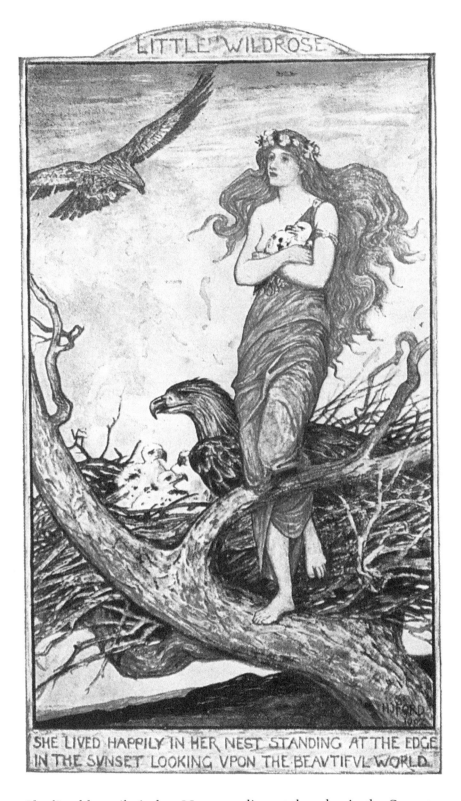

She lived happily in her Nest standing at the edge in the Sunset
looking upon the beautiful World
LITTLE WILDROSE

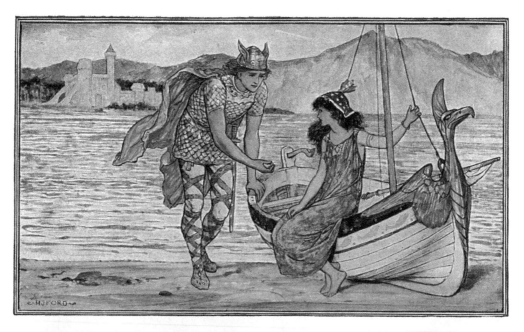

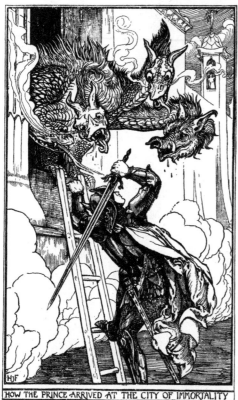

HOW THE PRINCE ARRIVED AT THE CITY OF IMMORTALITY

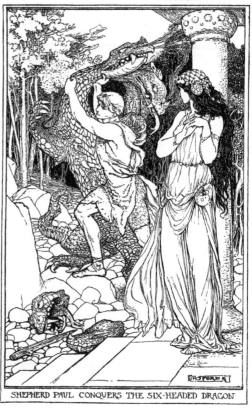

SHEPHERD PAUL CONQUERS THE SIX-HEADED DRAGON

Top: Sigurd meets Helga by the Lake and gives her a Ring
THE HORSE GULLFAXI AND THE SWORD GUNNFÖDER
Bottom left: How the Prince arrived at the City of Immortality
THE PRINCE WHO WOULD SEEK IMMORTALITY
Bottom right: Shepherd Paul conquers the Six-headed Dragon
SHEPHERD PAUL

The Crimson Fairy Book, 1903

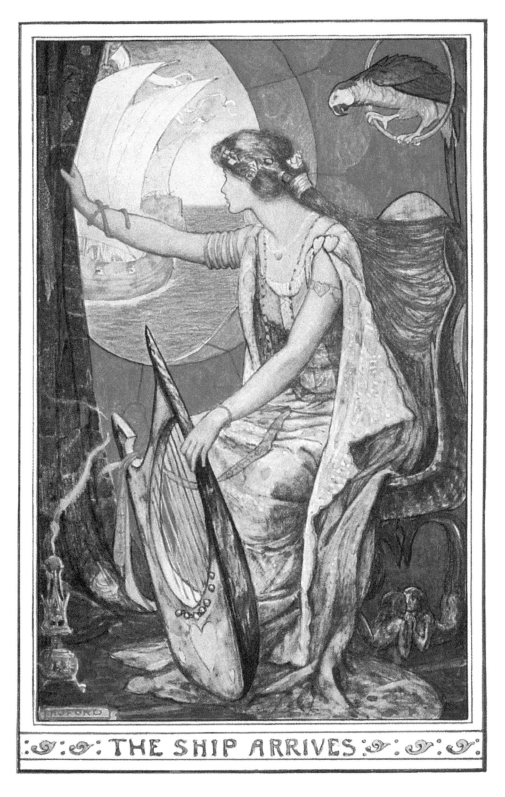

THE SHIP ARRIVES

The Ship Arrives
THE STORY OF THE SEVEN SIMONS

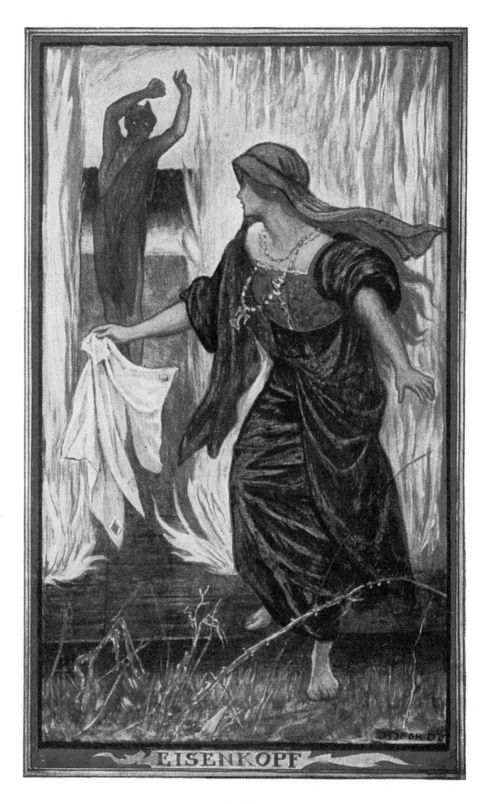

EISENKOPF

Eisenkopf

EISENKOPF

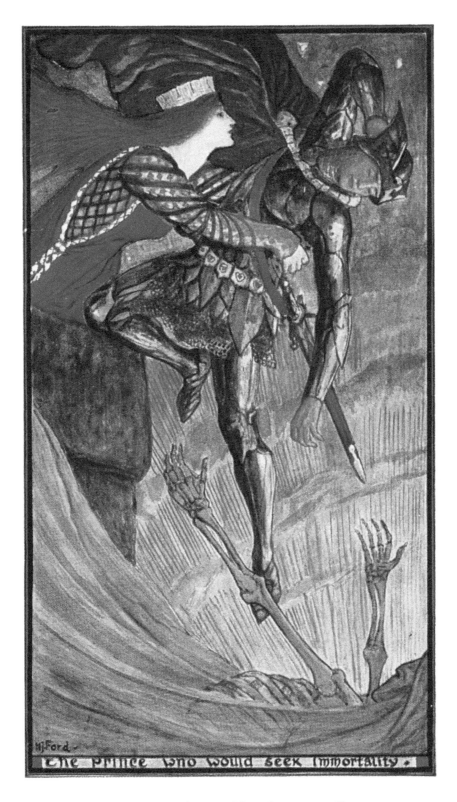

The Prince who would seek Immortality
THE PRINCE WHO WOULD SEEK IMMORTALITY

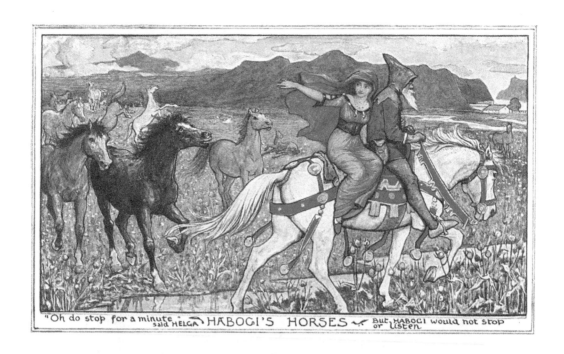

"Oh do stop for a minute" said HELGA HÁBOGI'S HORSES But HÁBOGI would not stop or listen

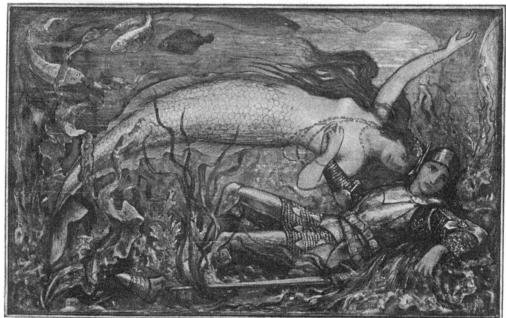

· LISTEN · LISTEN · SAID · THE · MERMAID · TO · THE · PRINCE ·

Top: Hábogi's Horses
HÁBOGI
Bottom: "Listen! Listen!" said the Mermaid to the Prince
THE MERMAID AND THE BOY

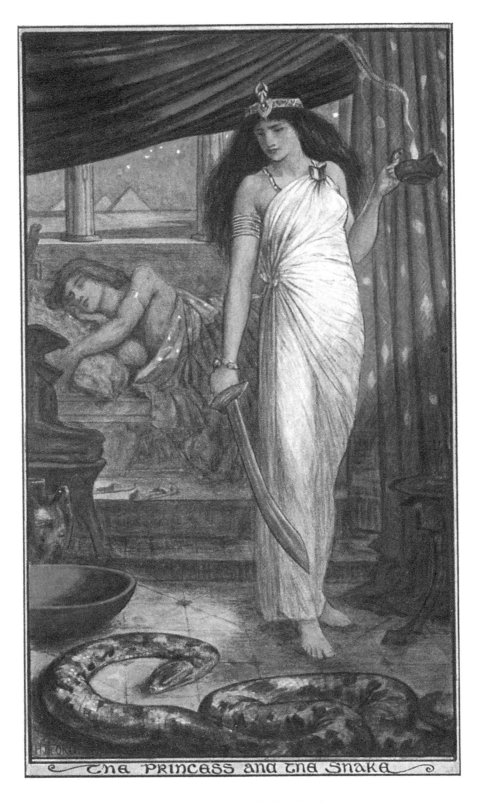

The Princess and the Snake
THE PRINCE AND THE THREE FATES

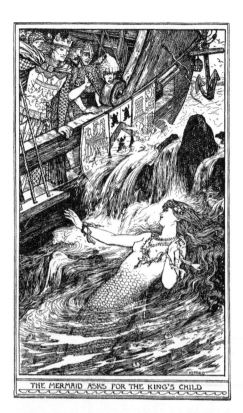

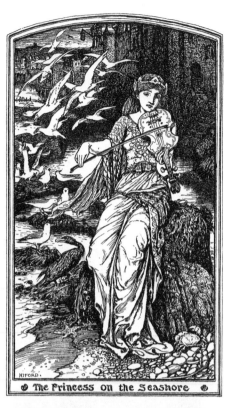

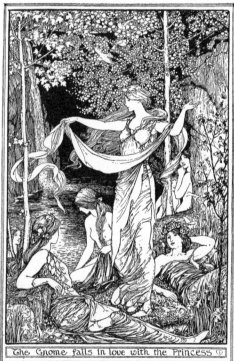

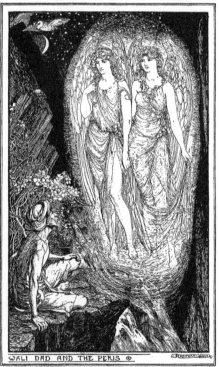

Top left: The Mermaid asks for the King's Child
Top right: The Princess on the Seashore
THE MERMAID AND THE BOY
Bottom left: The Gnome falls in love with the Princess, RÜBEZAHL
Bottom right: Wali Dâd and the Peris
STORY OF WALI DÂD THE SIMPLE-HEARTED

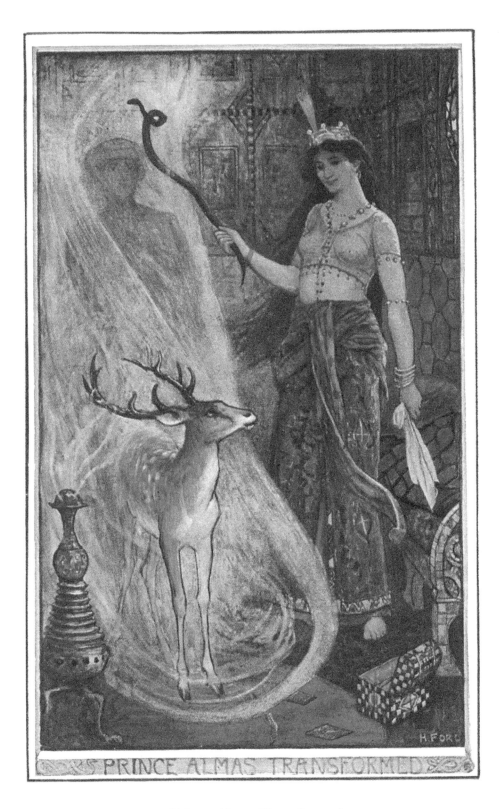

Prince Almas Transformed
WHAT THE ROSE DID TO THE CYPRESS

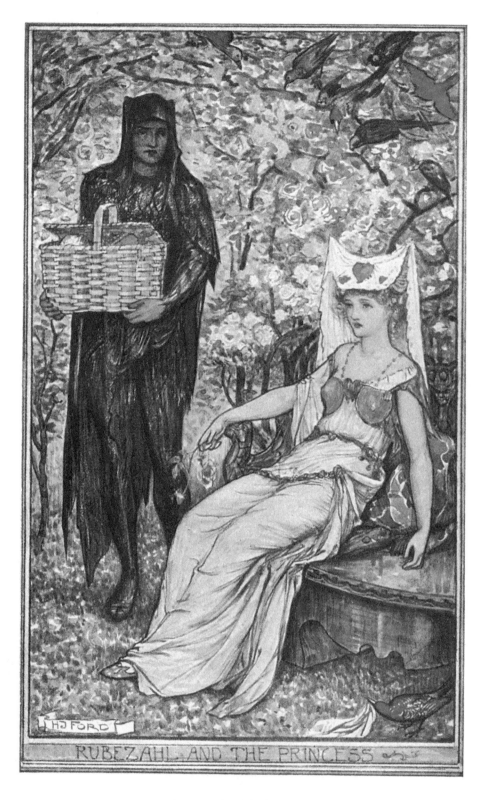

Rübezahl and the Princess

RÜBEZAHL

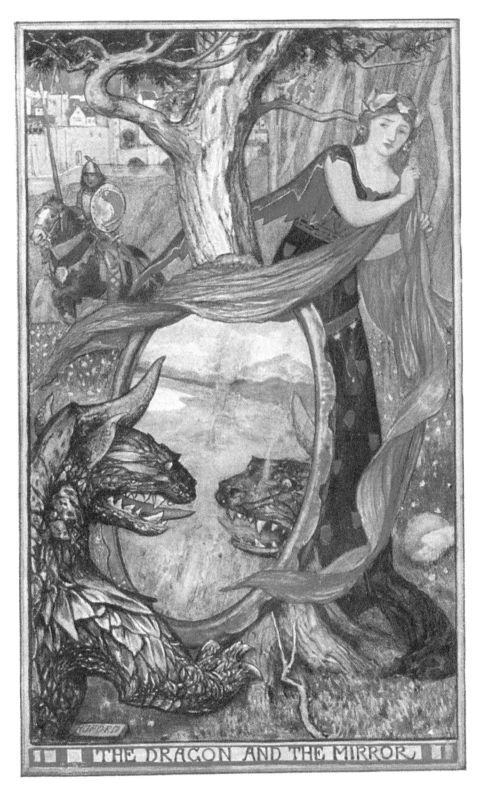

The Dragon and the Mirror
THE KNIGHTS OF THE FISH

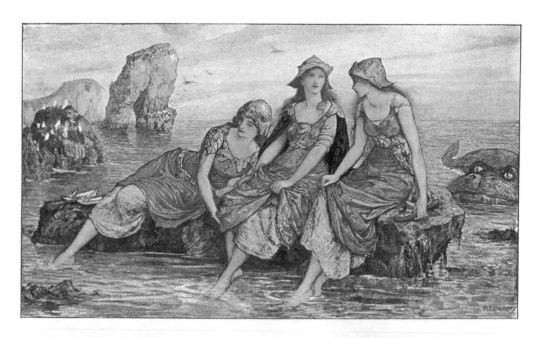

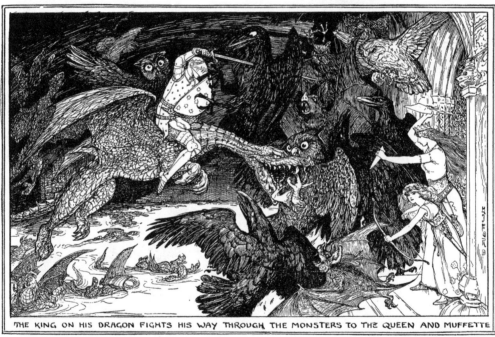

THE KING ON HIS DRAGON FIGHTS HIS WAY THROUGH THE MONSTERS TO THE QUEEN AND MUFFETTE

Top: The Three Maidens sitting on the Rocks
IAN, THE SOLDIER'S SON
Bottom: The King on his Dragon fights his way through the Monsters
to the Queen and Muffette
THE FROG AND THE LION FAIRY

The Orange Fairy Book, 1906

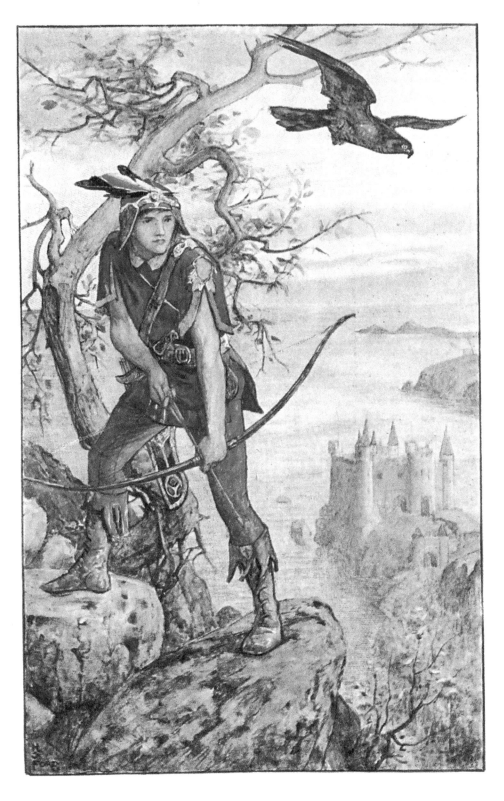

Ian and the Blue Falcon
HOW IAN DIREACH GOT THE BLUE FALCON

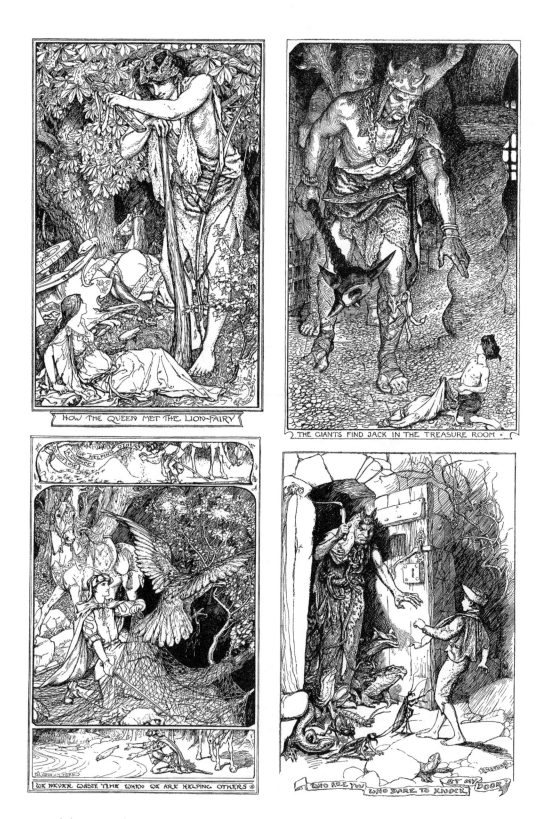

Top left: How the Queen met the Lion Fairy, THE FROG AND THE LION FAIRY
Top right: The Giants find Jack in the Treasure Room
THE THREE TREASURES OF THE GIANTS
Bottom left: "We never waste time when we are helping others"
THE PRINCESS BELLA-FLOR
Bottom right: "Who are you who dare to knock at my door?"
THE BIRD OF TRUTH

66 *The Orange Fairy Book,* 1906

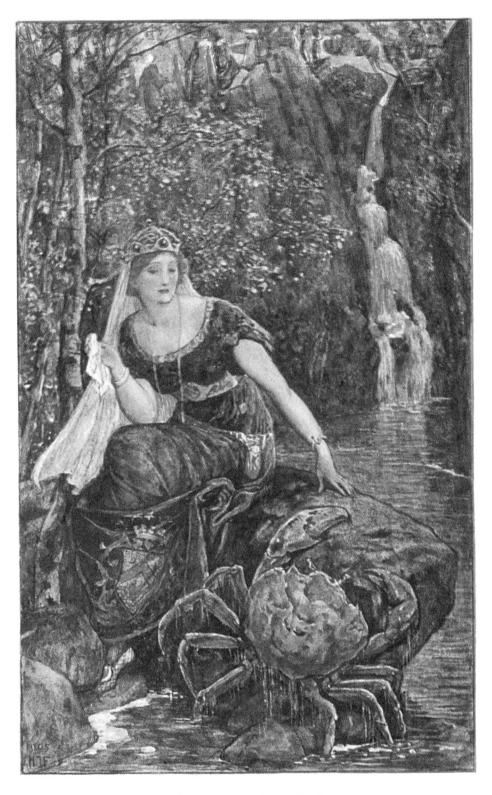

The Queen and the Crab
THE WHITE DOE

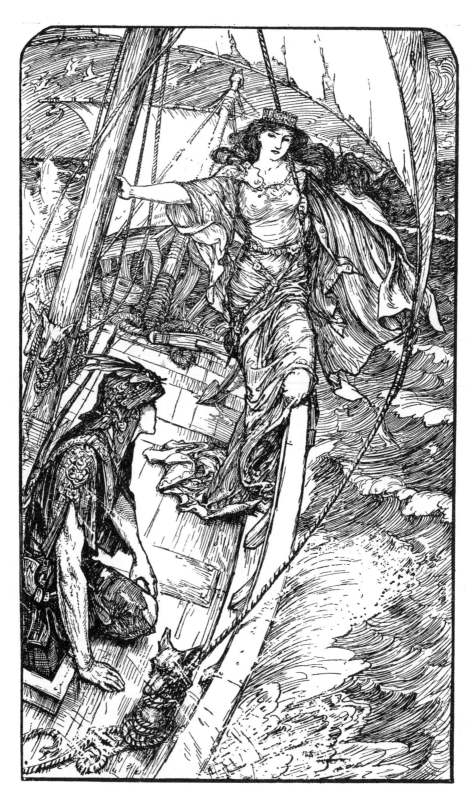

The Princess finds herself a Prisoner on the Ship
HOW IAN DIREACH GOT THE BLUE FALCON

The Orange Fairy Book, 1906

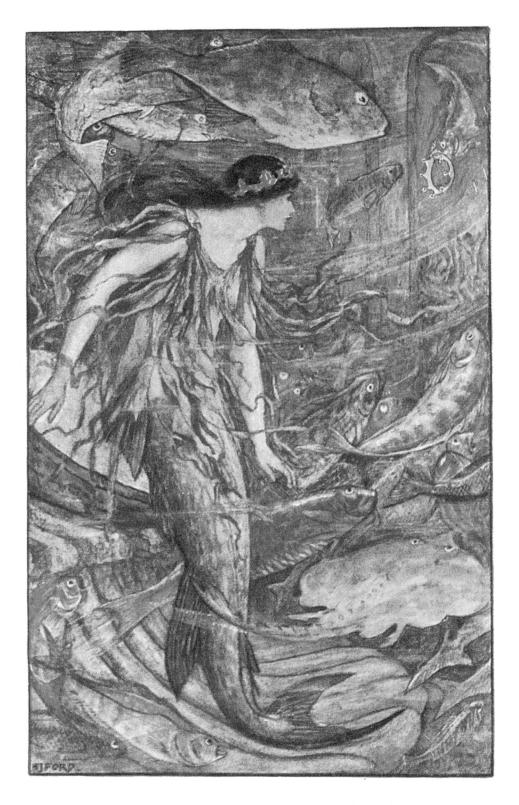

The Crown returns to the Queen of the Fishes
THE GIRL-FISH

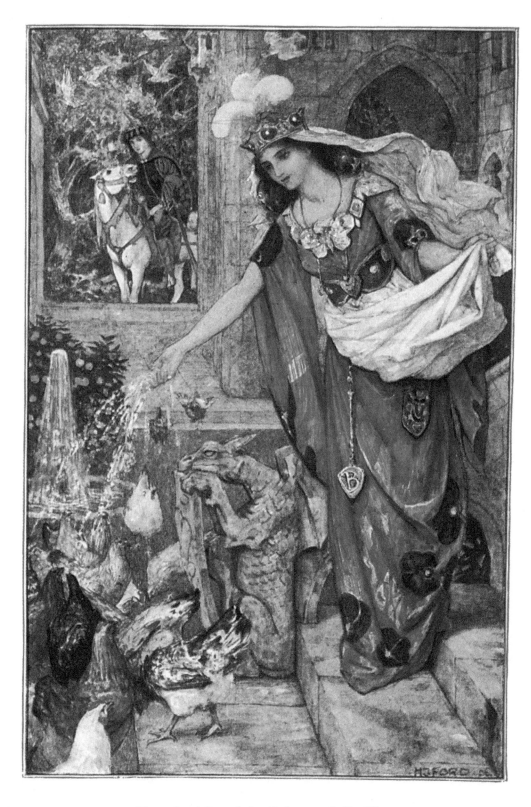

How José found the Princess Bella-Flor
THE PRINCESS BELLA-FLOR

The Orange Fairy Book, 1906

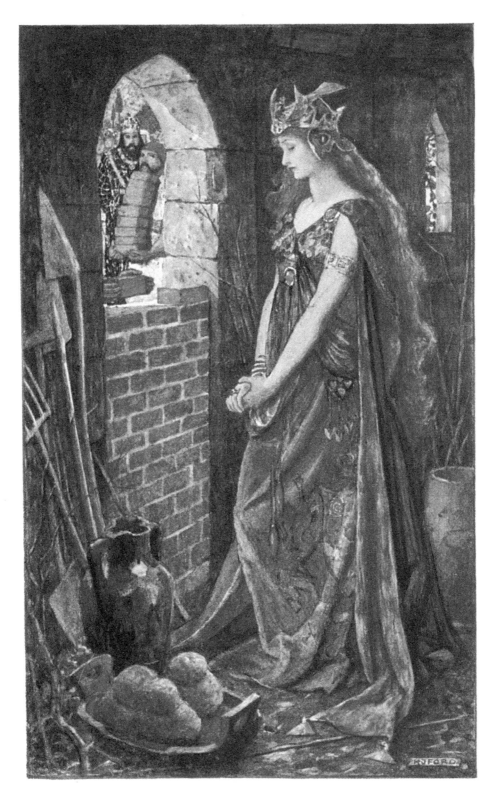

The Princess imprisoned in the Summer-house
THE MAGIC BOOK

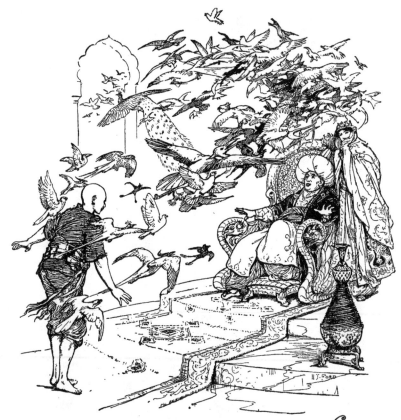

How the Birds were brought to the Sultan

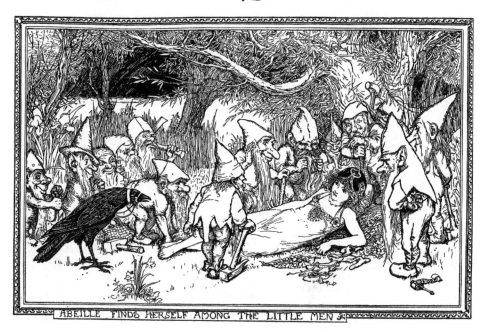

ABEILLE FINDS HERSELF AMONG THE LITTLE MEN

Top: How the Birds were brought to the Sultan
MADSCHUN
Bottom: Abeille finds herself among the Little Men
THE STORY OF LITTLE KING LOC

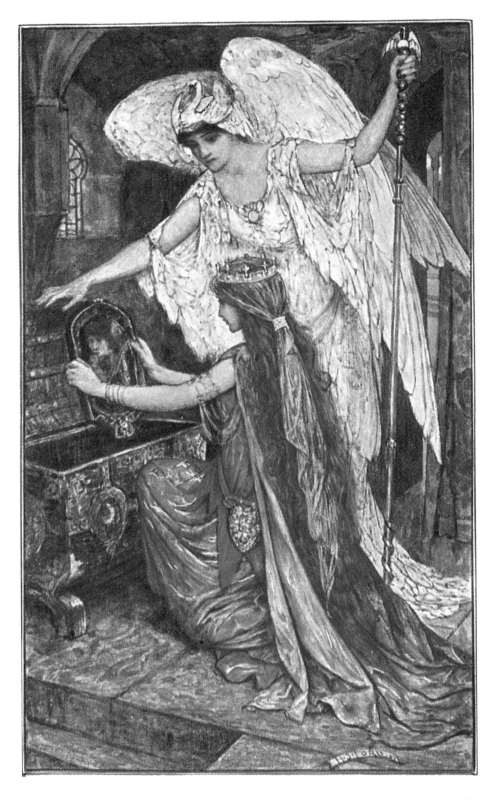

In this mirror she could see faithfully reflected whatever she wished
THE BLUE PARROT

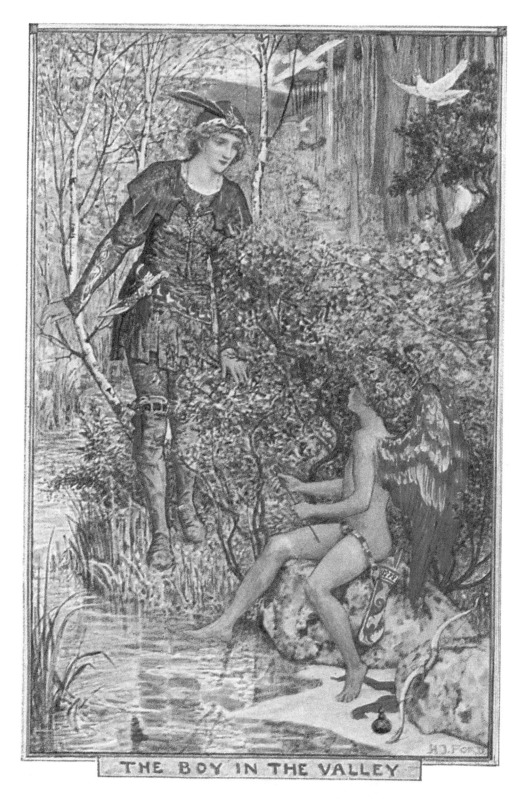

THE BOY IN THE VALLEY

The Boy in the Valley
THE SATIN SURGEON

The Olive Fairy Book, 1907

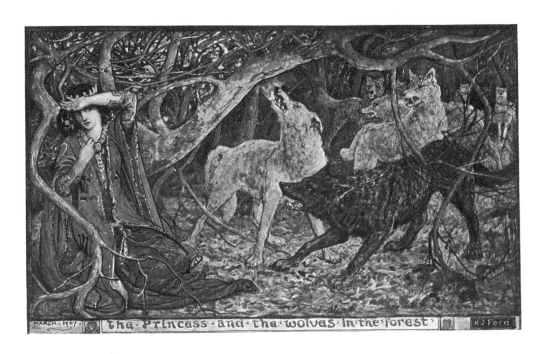

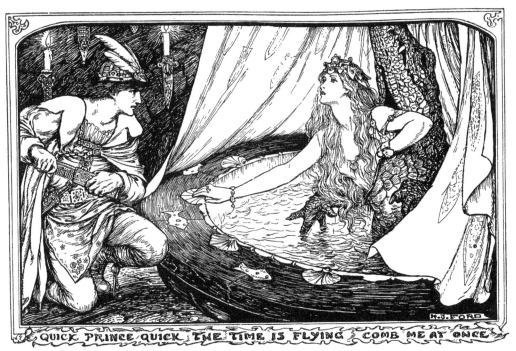

Top: The Princess and the Wolves in the Forest
Bottom: "Quick! prince! quick! the time is flying, comb me at once"
THE COMB AND THE COLLAR

The Olive Fairy Book, 1907

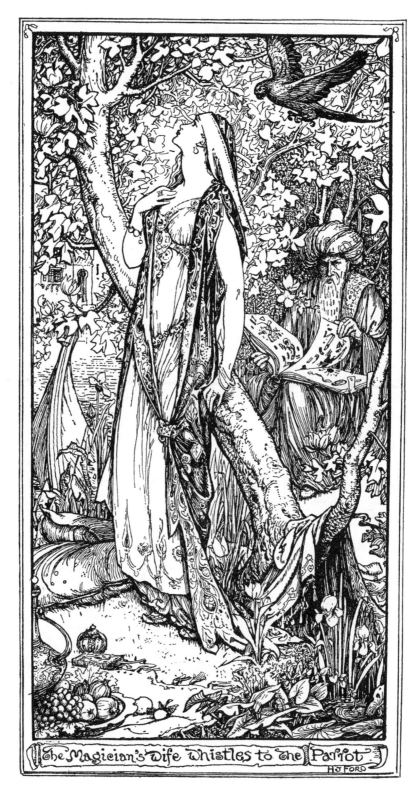

The Magician's Wife whistles to the Parrot
THE BLUE PARROT

The Olive Fairy Book, 1907

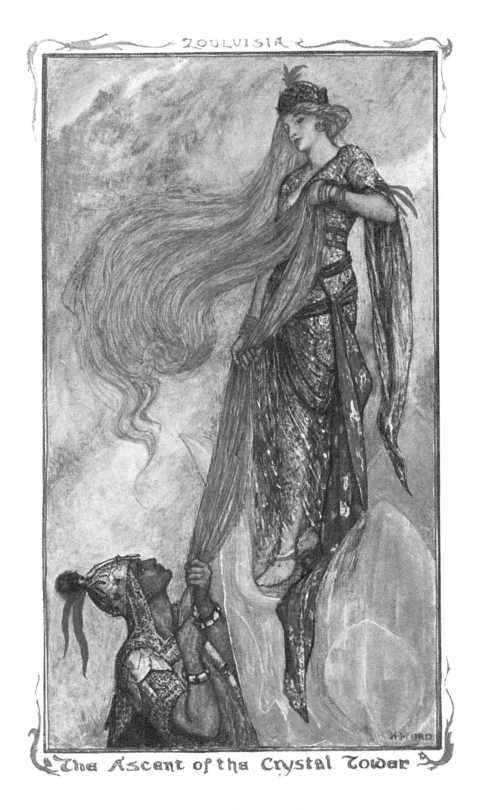

The Ascent of the Crystal Tower
THE STORY OF ZOULVISIA

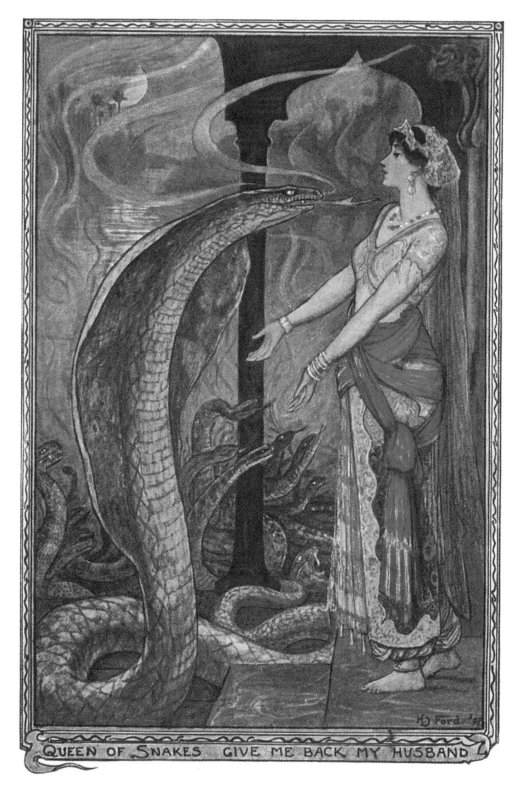

"Queen of Snakes, give me back my husband!"
THE SNAKE PRINCE

The Olive Fairy Book, 1907

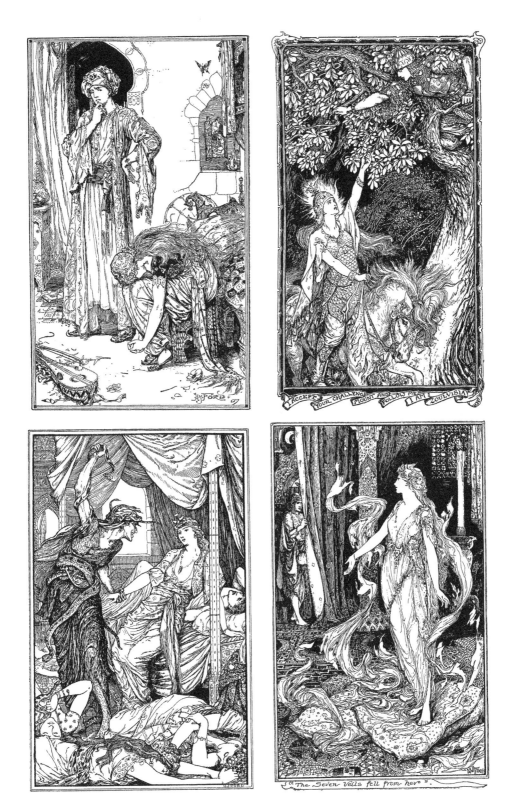

Top left: "He never could persuade her to say a single word"
DORANI
Top right: "I accept your challenge. Mount, and follow me. I am Zoulvisia"
Bottom left: The Witch and her Snakes
THE STORY OF ZOULVISIA
Bottom right: "The seven veils fell from her," THE SILENT PRINCESS

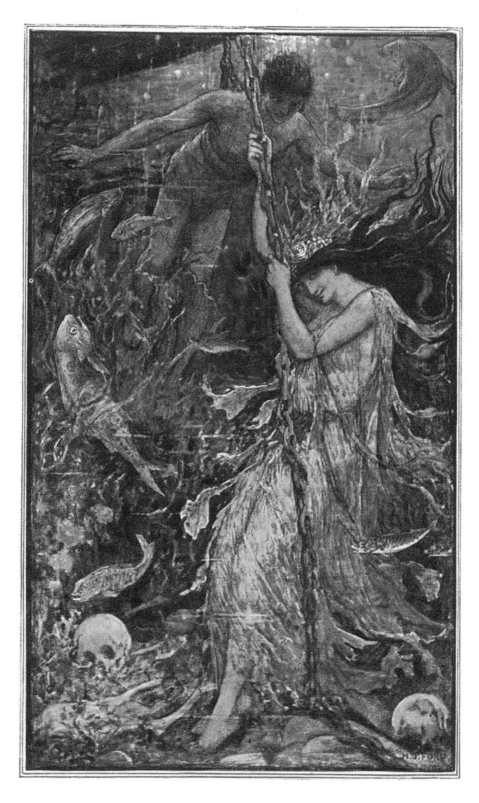

The Sea-maiden with a wicked Face
THE BOY WHO FOUND FEAR AT LAST

The Olive Fairy Book, 1907

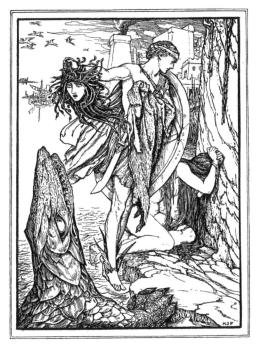
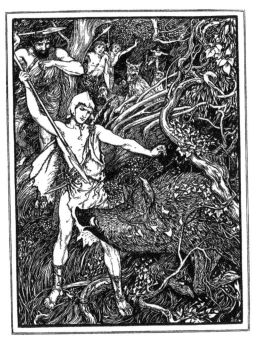
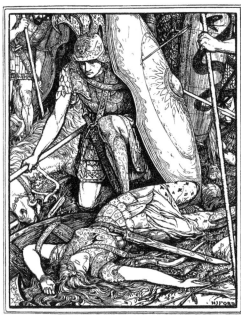
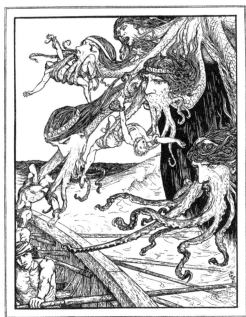

Top left: The Rescue of Andromeda, PERSEUS
Top right: Ulysses, when a youth, fights the wild boar
and gets his wound in his thigh
Bottom left: Achilles pities Penthesilea after slaying her
ULYSSES THE SACKER OF CITIES
Bottom right: The Adventure with Scylla, THE WANDERINGS OF ULYSSES

Tales of Troy and Greece, 1907

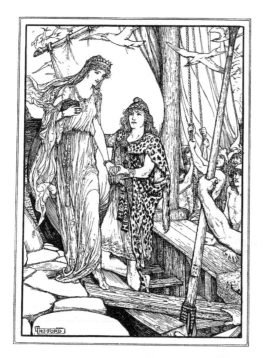

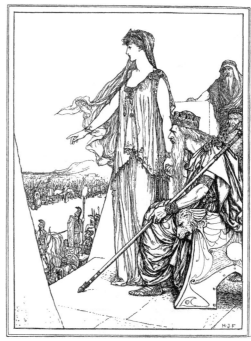

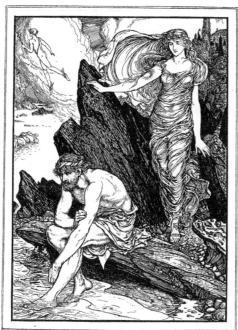

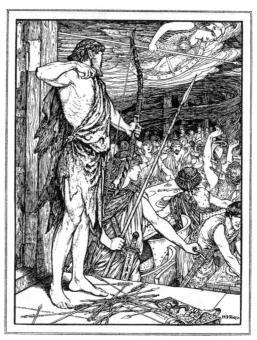

Top left: The Stealing of Helen
Top right: Helen points out the chief heroes in the Greek host to Priam
ULYSSES THE SACKER OF CITIES
Bottom left: Calypso takes pity on Ulysses
Bottom right: Ulysses shoots the first arrow at the wooers
THE WANDERINGS OF ULYSSES

Tales of Troy and Greece, 1907

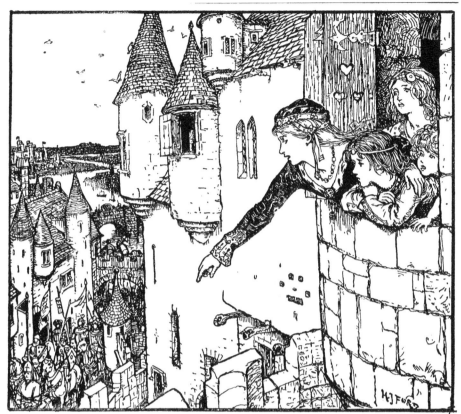

LOOK LOOK SHE CRIED TO HER BROTHERS & SISTERS

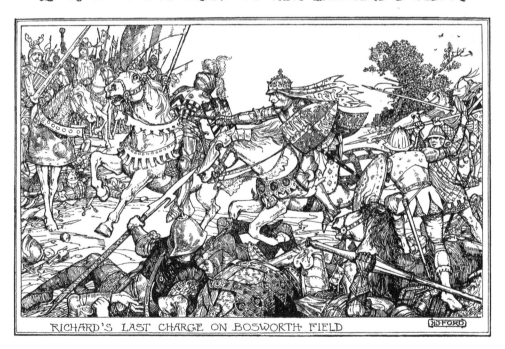

RICHARD'S LAST CHARGE ON BOSWORTH FIELD

Top: "Look, look!" she cried to her brothers and sisters
THE "LITTLE QUEEN"

Bottom: Richard's last Charge on Bosworth Field
THE RED ROSE

The Book of Princes and Princesses, 1908

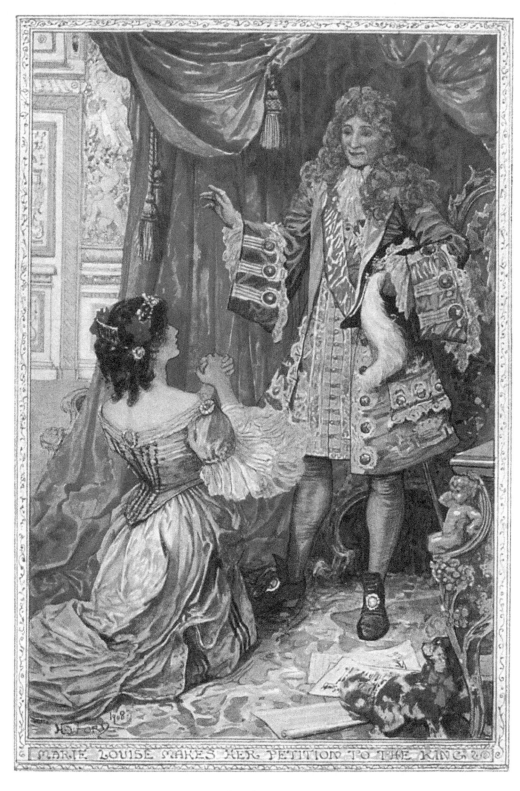

Marie Louise makes her Petition to the King
Mi Reina! Mi Reina!

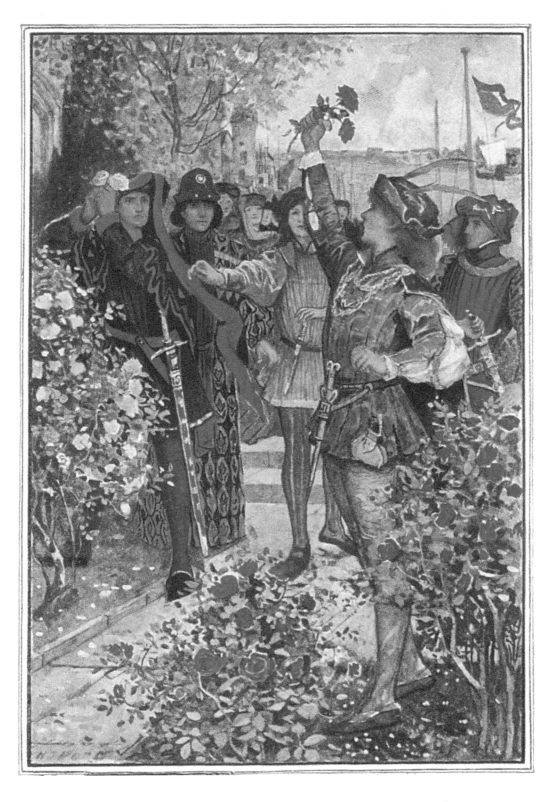

The Red Rose for Lancaster, The White Rose for York
THE RED ROSE

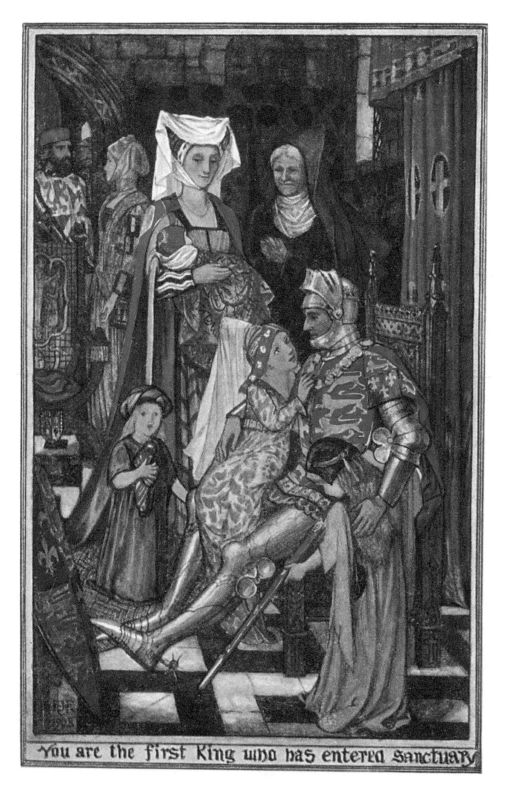

You are the first King who has entered Sanctuary
THE WHITE ROSE

The Book of Princes and Princesses, 1908

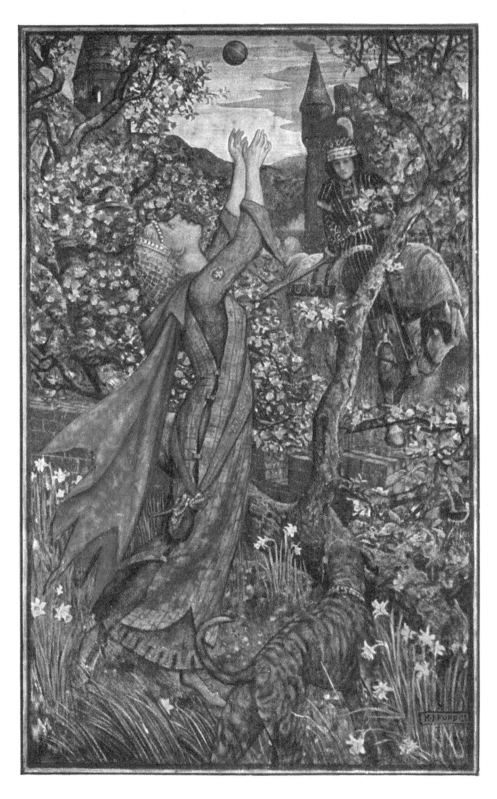

"How the King found the girl playing at ball in the orchard"
THE FALSE PRINCE AND THE TRUE

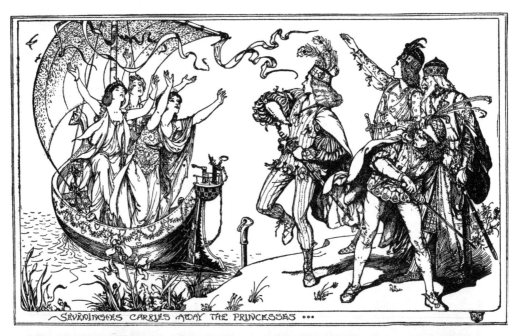

SEVEN INCHES CARRIES AWAY THE PRINCESSES...

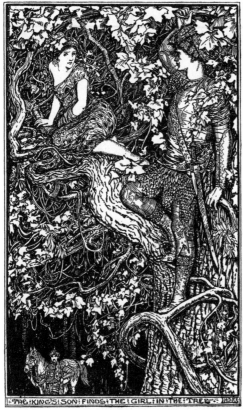

THE KING'S SON FINDS THE GIRL IN THE TREE

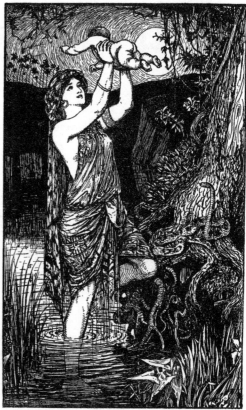

Top: Seven Inches carries away the princesses
THE THREE CROWNS
Bottom left: The King's son finds the girl in the tree
THE ONE-HANDED GIRL
Bottom right: "My baby, my baby!"
THE ONE-HANDED GIRL

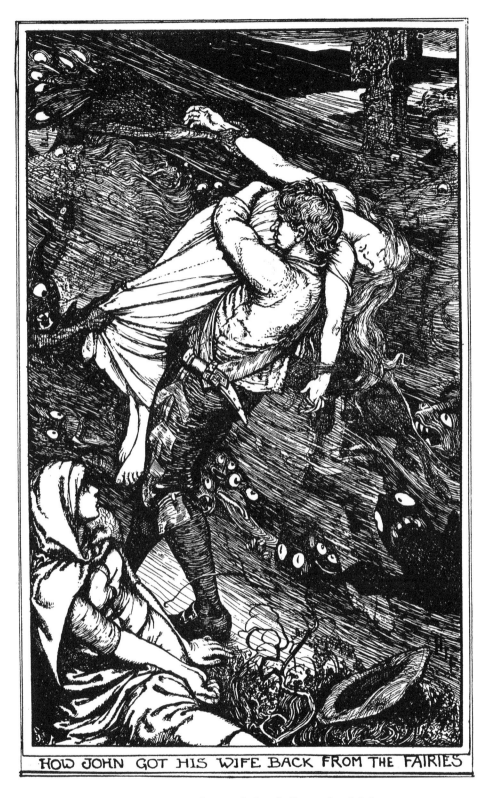

How John got his wife back from the fairies
THE FAIRY NURSE

The Lilac Fairy Book, 1910

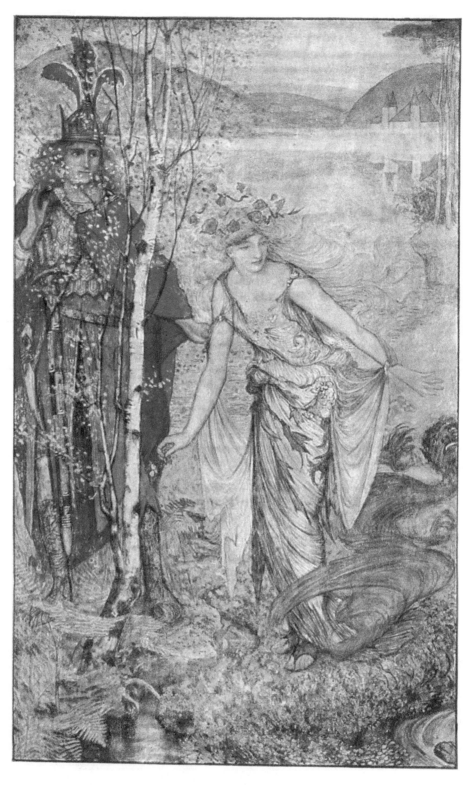

"When she stood upright her ugliness had all gone"
THE KING OF THE WATERFALLS

The Lilac Fairy Book, 1910

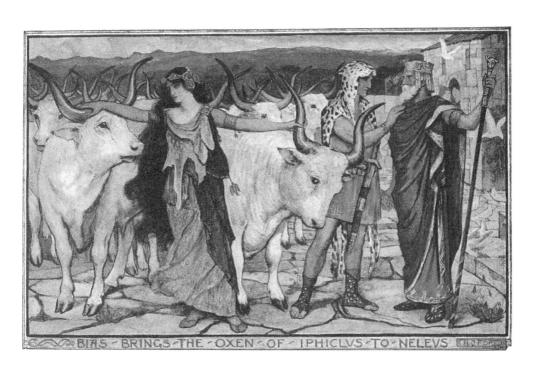

BIAS·BRINGS·THE·OXEN·OF·IPHICLVS·TO·NELEVS

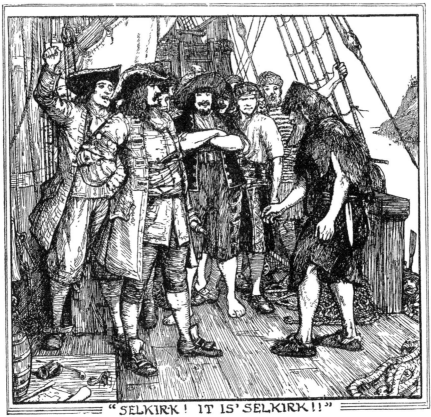

"SELKIRK! IT IS SELKIRK!!"

Top: Bias brings the Oxen of Iphiclus to Neleus
THE SERPENTS' GIFT
Bottom: "Selkirk! It is Selkirk!!"
THE REAL ROBINSON CRUSOE

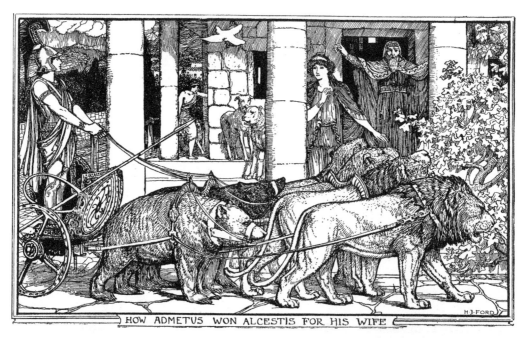

HOW ADMETUS WON ALCESTIS FOR HIS WIFE

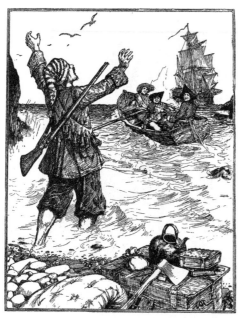

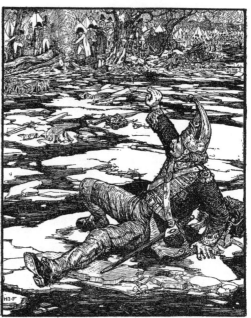

Top: How Admetus won Alcestis for his Wife
HERACLES THE DRAGON-KILLER
Bottom left: Selkirk implores to be taken back to the ship
THE REAL ROBINSON CRUSOE
Bottom right: The Wounded Russian calls to Napoleon from the Ice
HOW THE RUSSIAN SOLDIER WAS SAVED

The All Sorts of Stories Book, 1911

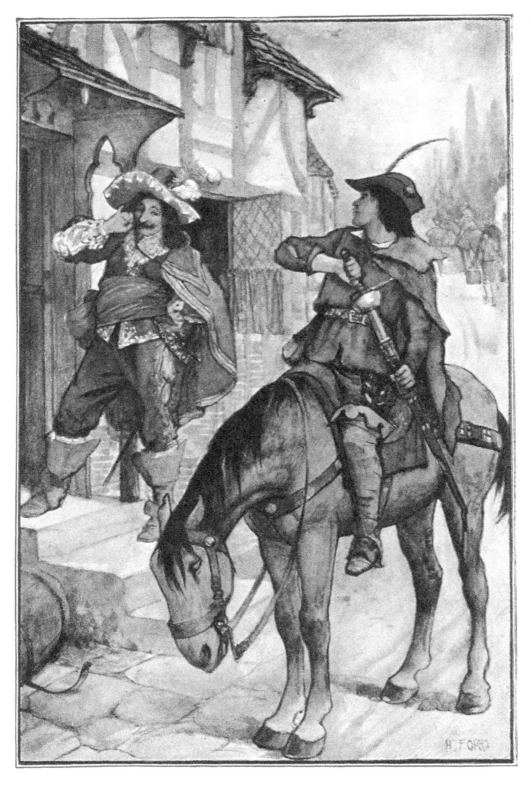

D'Artagnan will not have his Horse laughed at
THE SWORD OF D'ARTAGNAN

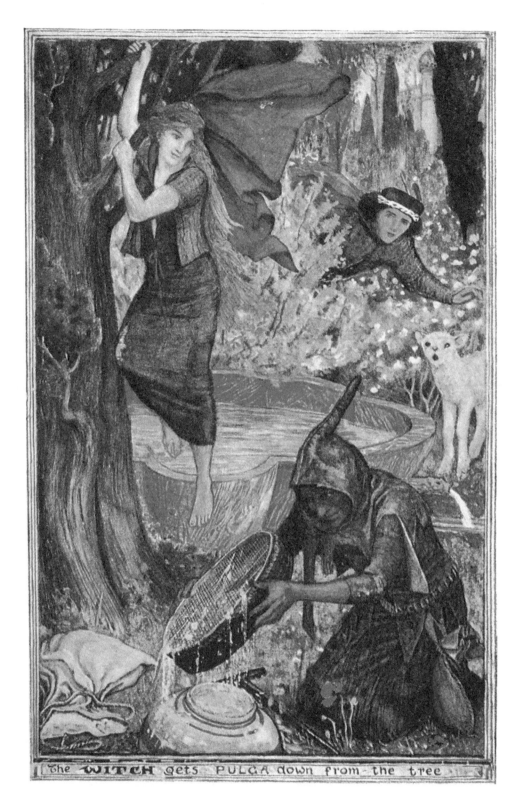

The Witch gets Pulja down from the Tree
HOW A BOY BECAME FIRST A LAMB AND THEN AN APPLE

The All Sorts of Stories Book, 1911

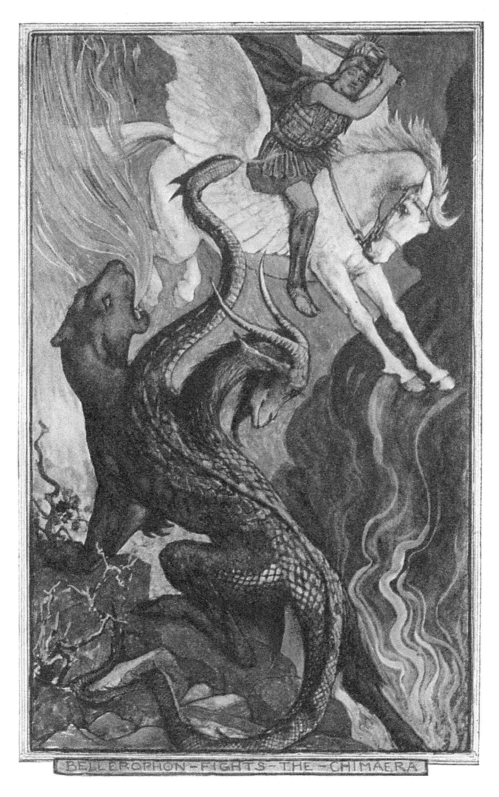

Bellerophon fights the Chimæra
THE HORSE WITH WINGS

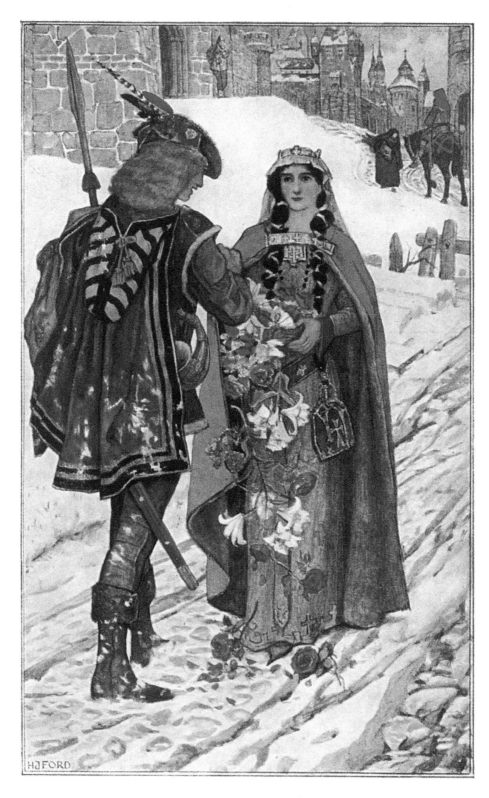

The Miracle of the Roses and Lilies
St. Elizabeth of Hungary

The Book of Saints and Heroes, 1912

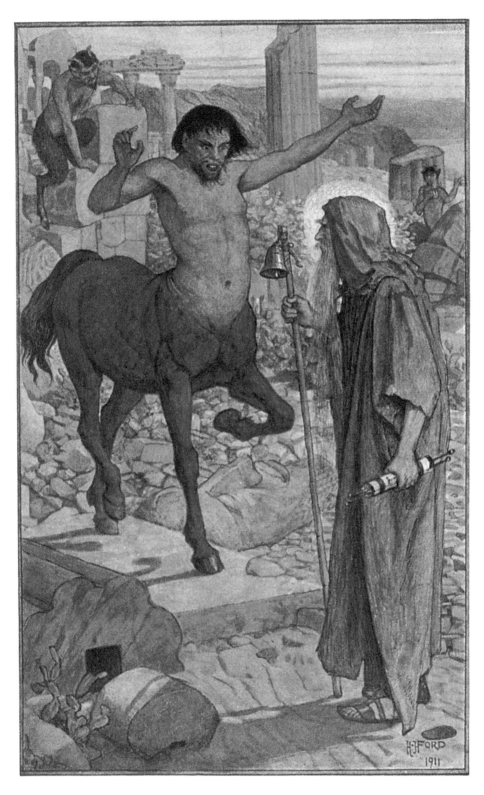

How St. Anthony met a centaur and a satyr
THE FIRST OF THE HERMITS

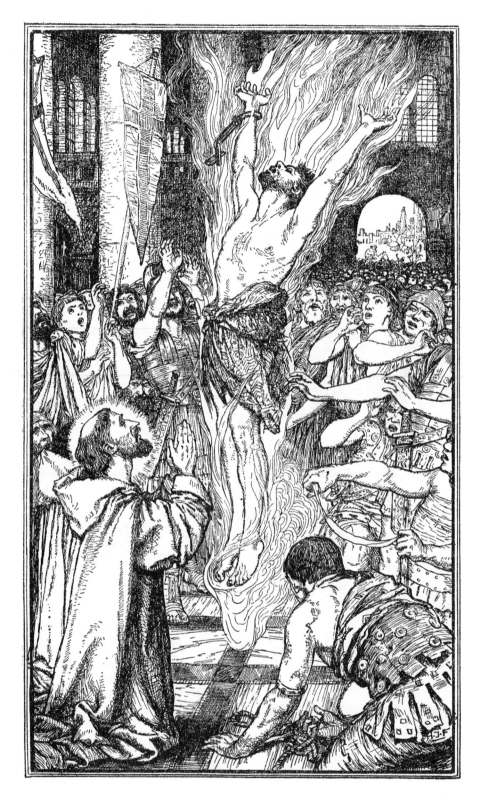

Germanus and the man possessed
GERMANUS THE GOVERNOR

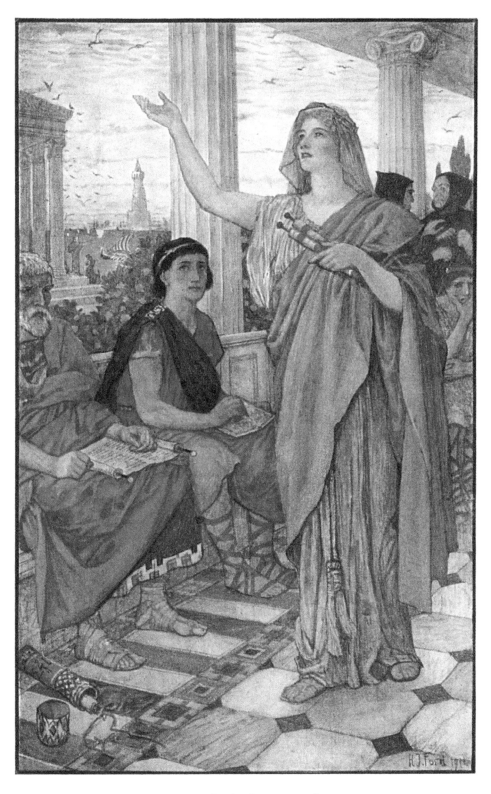

Synesius attends the lectures of Hypatia
SYNESIUS, THE OSTRICH HUNTER

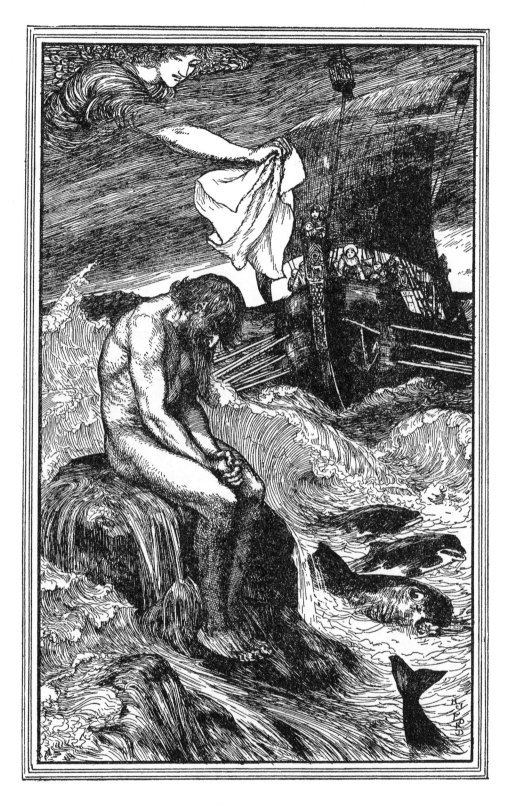

How St. Brendan found Judas Iscariot
BRENDAN THE SAILOR

The Book of Saints and Heroes, 1912

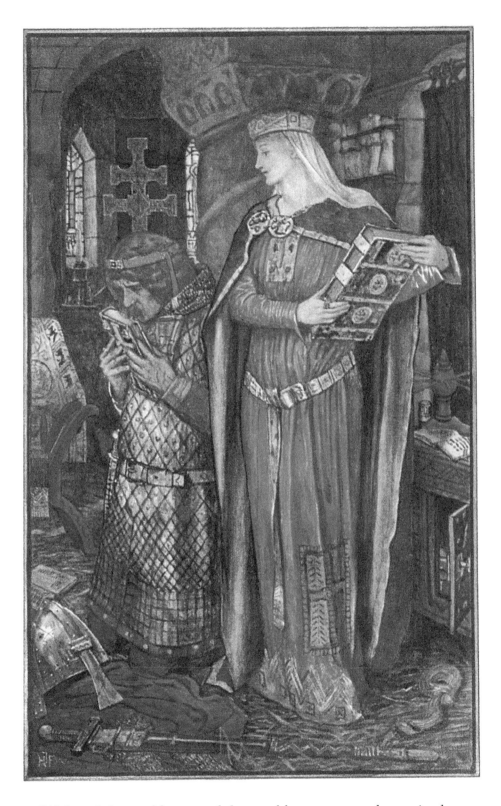

"Although he could not read, he would turn over and examine her
books, and kiss those which he liked best"
ST. MARGARET OF SCOTLAND

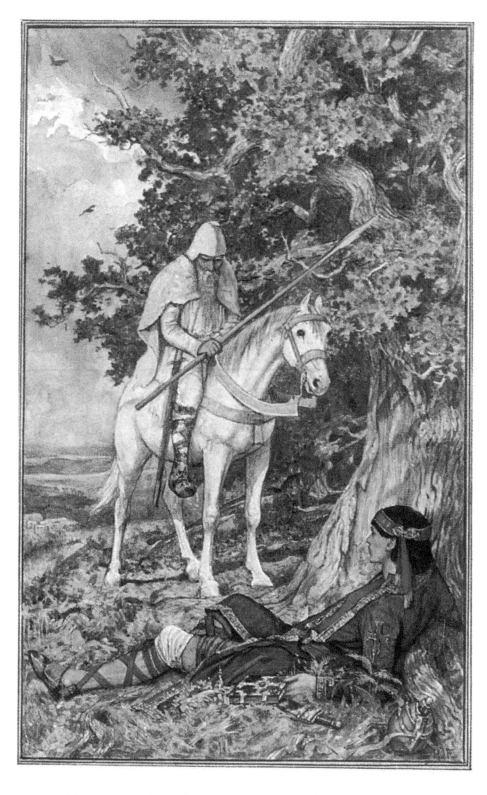

The man on the White Horse comes to heal St. Cuthbert
THE APOSTLE OF NORTHUMBRIA

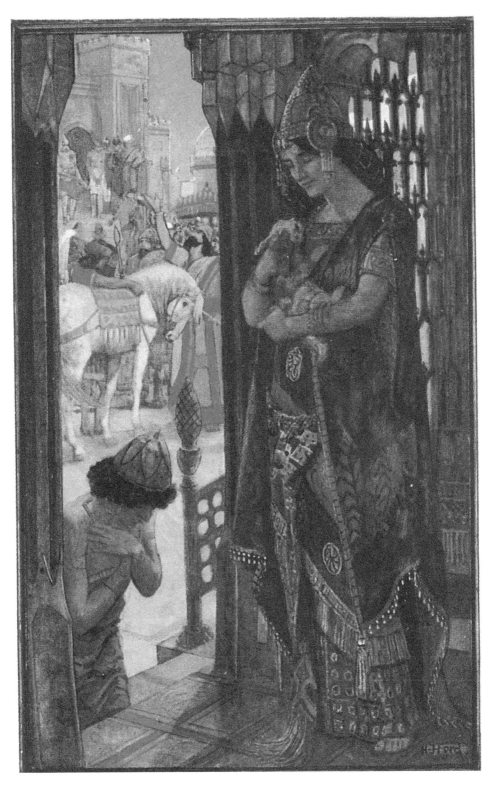

The King and Queen rejoice when their Pets return
THE PERPLEXITY OF ZADIG

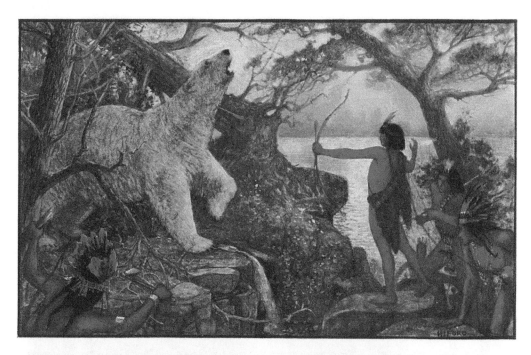

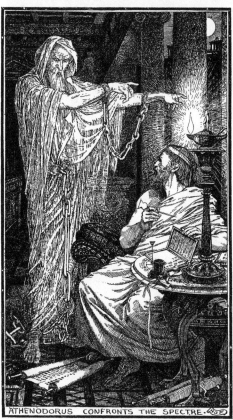

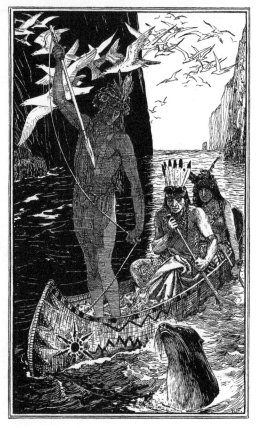

Top: How the Boy shot the White Bear
GROWING-UP-LIKE-ONE-WHO-HAS-A-GRANDMOTHER
Bottom left: Athenodorus Confronts the Spectre
AN OLD-WORLD GHOST
Bottom right: The Dead Son helps his Parents
LAND-OTTER THE INDIAN

The Strange Story Book, 1913

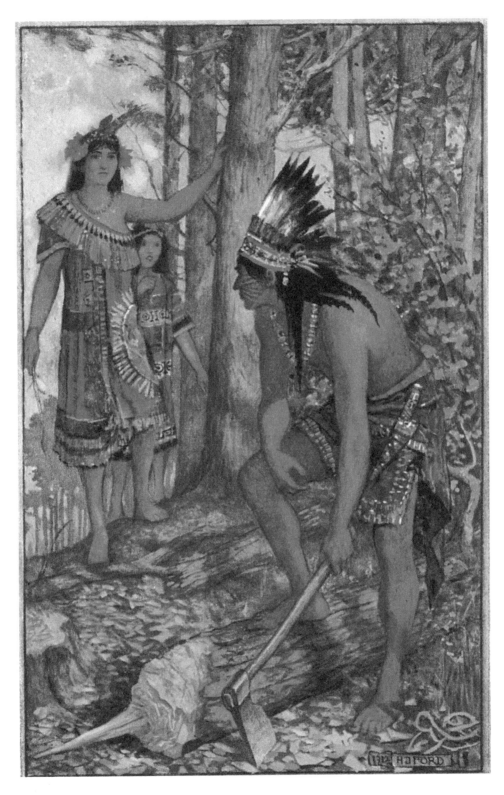

How the Girls found Mountain Dweller
THE WONDERFUL BASKET

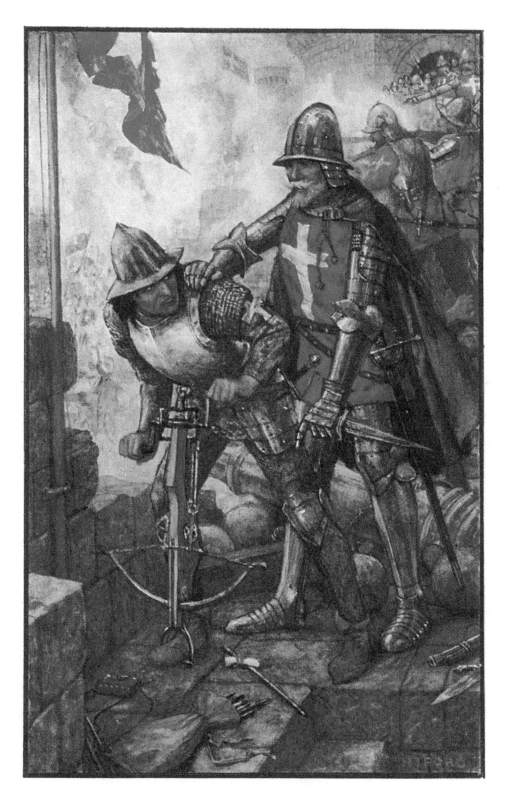

Discovering the Traitor
THE SIEGE OF RHODES

The Strange Story Book, 1913

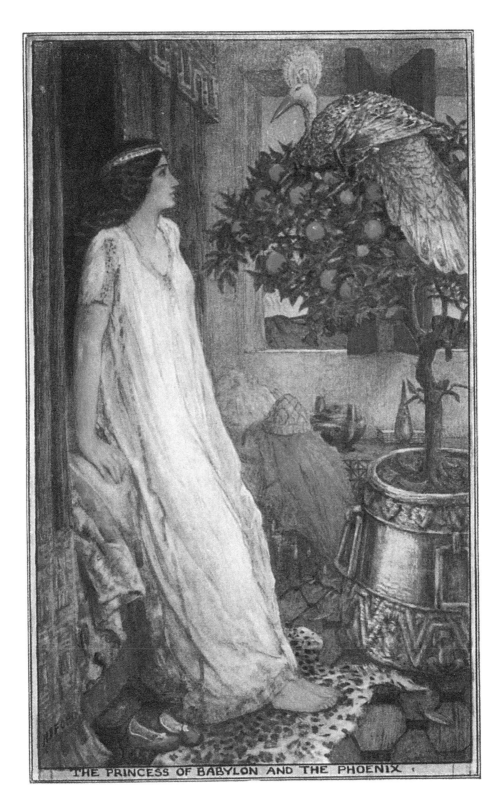

The Princess of Babylon and the Phœnix
THE PRINCESS OF BABYLON

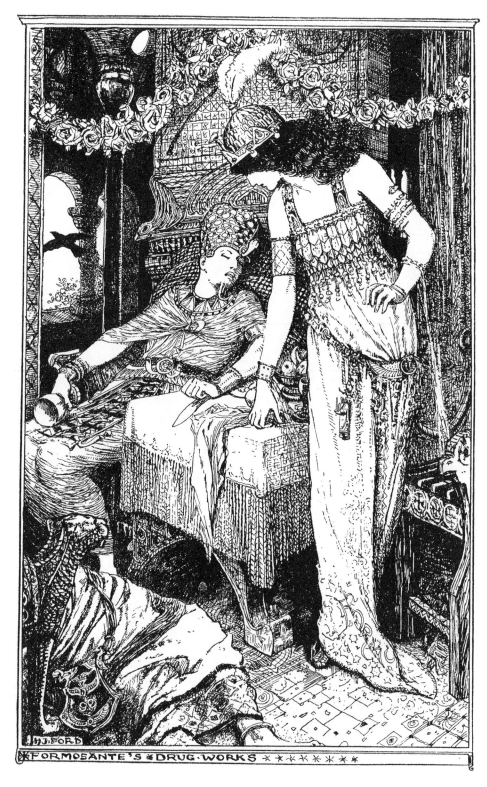

Formosante's Drug works
THE PRINCESS OF BABYLON

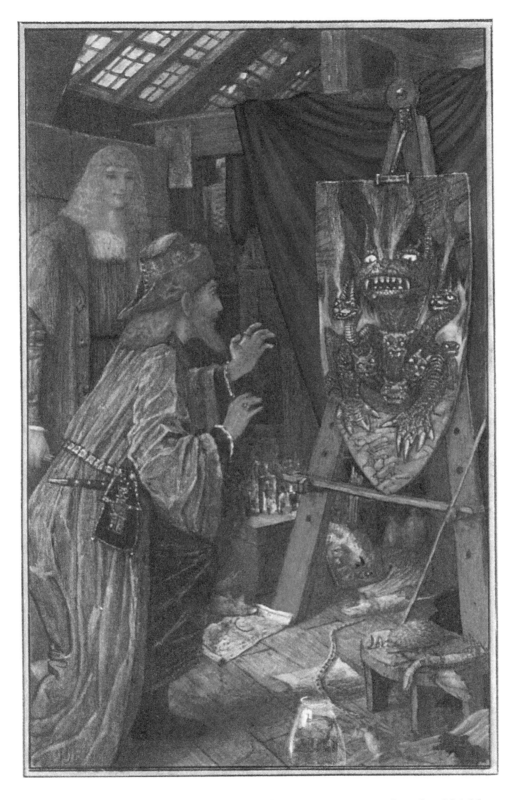

Leonardo frightens his Father with the Monster painted on his Shield
THE BOYHOOD OF A PAINTER

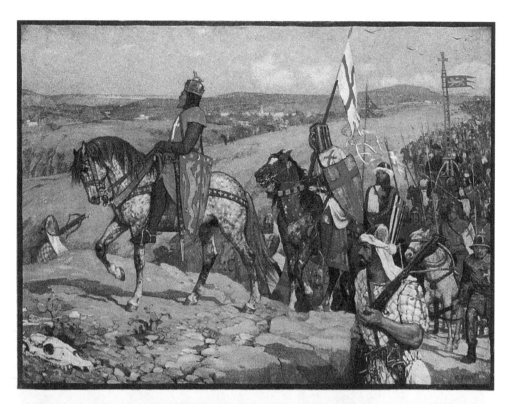

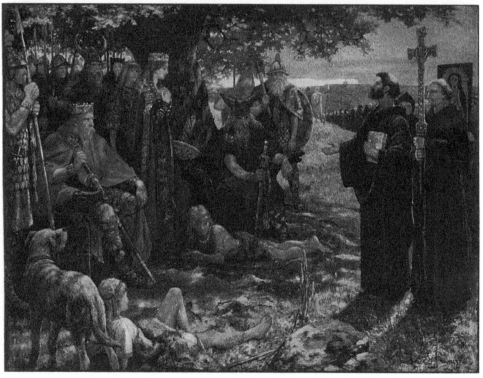

Top: Richard "The Lion-Hearted" Approaching Jerusalem
THE COMING OF THE NORMANS
Bottom: St. Augustine Preaching before King Ethelbert
THE SPREAD OF CHRISTIANITY

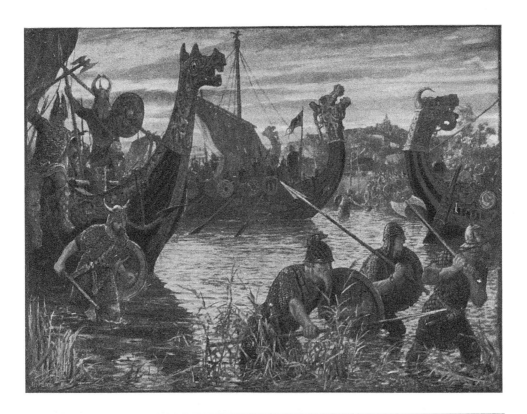

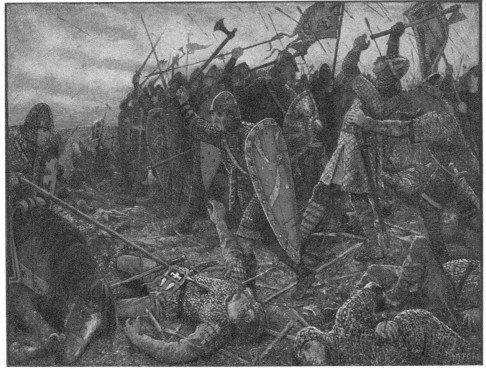

Top: A Danish Raid in Britain
ALFRED AND THE ENGLISH
Bottom: Harold's Last Stand at Senlac
THE COMING OF THE NORMANS

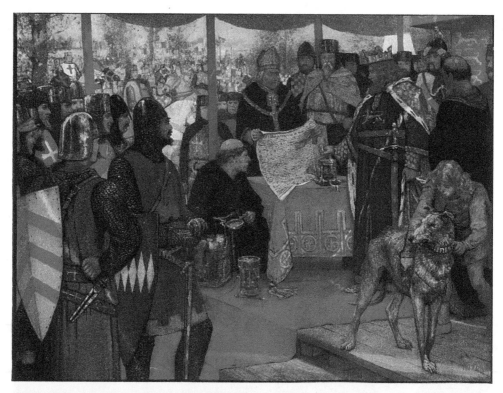

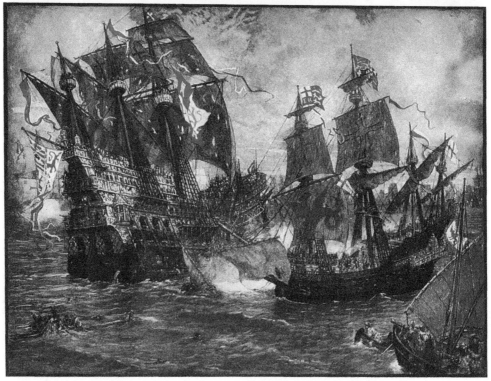

Top: King John Seals the Great Charter
KING JOHN AND THE FIGHT FOR ENGLISH LIBERTY
Bottom: Sir Francis Drake Capturing Don Pedro's Ship
ENGLISHMEN JOIN IN THE FIGHT AGAINST SPAIN

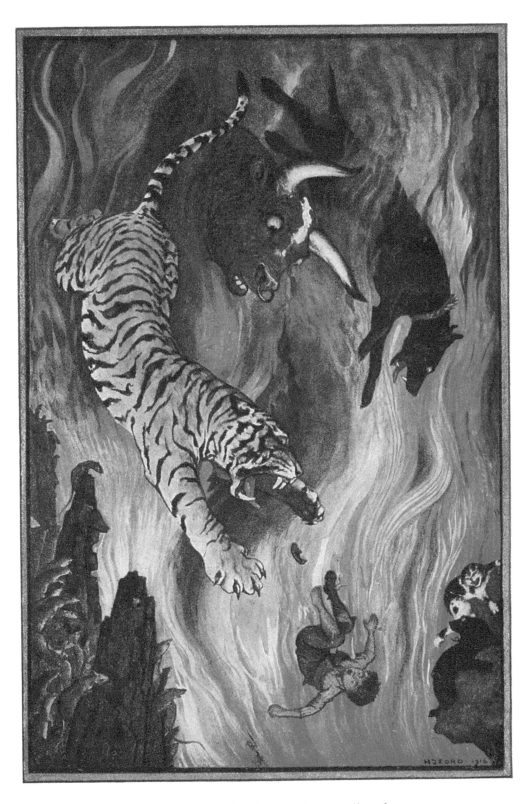

With a roar the tiger and the bull and
the black dog leapt upon him
THE BIRTHDAY

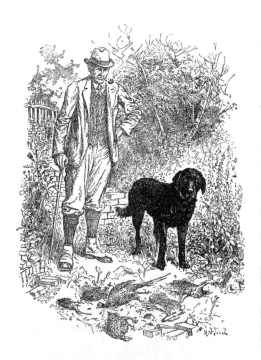

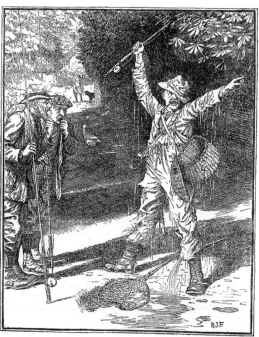

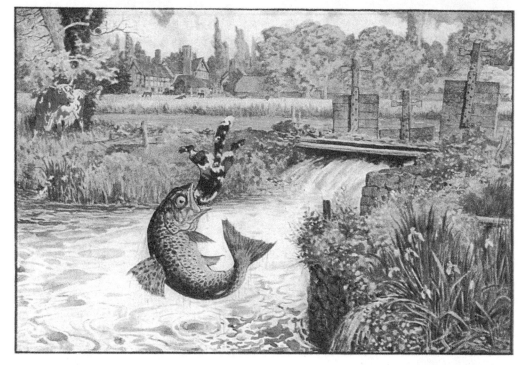

Top left: Pilot was literally dumbfounded
Top right: "See him? I should think I did"
PILOT
Bottom: He had once been seen to leap out of the water and swallow
Smith's tortoise-shell cat
IRON-BLUE

Pilot and Other Stories, 1916

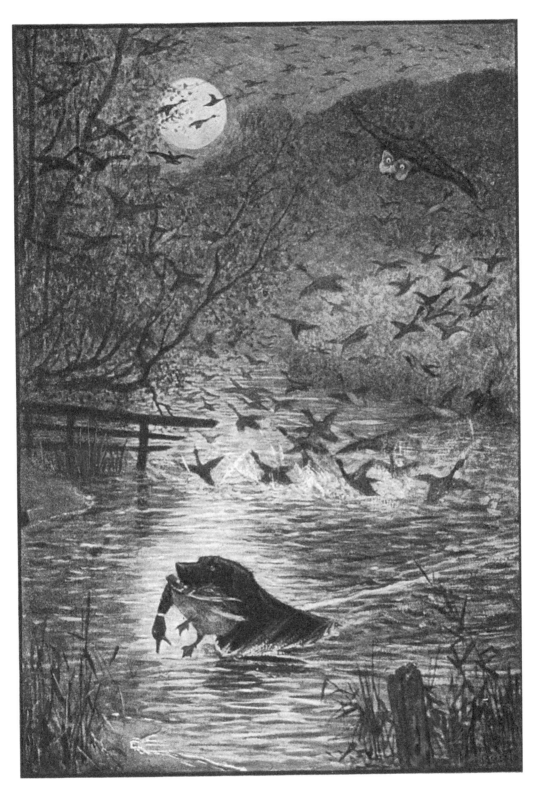

Wild Duck for supper to-night
PILOT